Art Matters

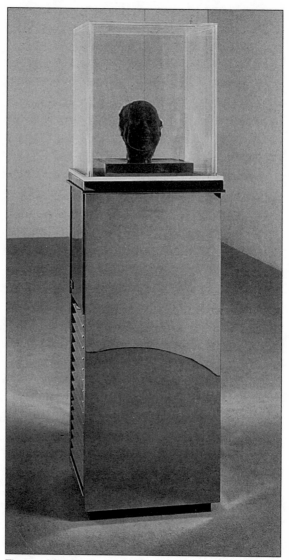

Figure 1. Marc Quinn, *Self*, blood, stainless steel, perspex, and refrigeration equipment, 1991. The Saatchi Gallery, London. © the artist.

Art Matters

Peter de Bolla

HARVARD UNIVERSITY PRESS
Cambridge, Massachusetts
London, England
2001

PRINTED IN THE UNITED STATES OF AMERICA

Library of Congress Cataloging-in-Publication Data

De Bolla, Peter, 1957–
Art matters / Peter de Bolla.
p. cm.
Includes bibliographical references and index.
ISBN 0-674-00649-6 (alk. paper)
1. Arts—Philosophy. 2. Aesthetics. I. Title.

BH39 .D4 2001
700'.1—dc21

2001039222

For E. C. De Bolla
and Christine Adams

Acknowledgments

Parts of this book have been gestating for a very long time; the earliest piece of writing on Wordsworth's *We Are Seven* was completed, albeit in a slightly different form, in 1986–1987. It was subsequently given as a paper on a number of occasions at universities in Great Britain, mainland Europe, and North America. Its latest outing was at the University of Copenhagen in 1999. The chapter on Barnett Newman came into shape next, and parts of it have been published, again in a slightly altered form, in Salim Kemal and Ivan Gaskell, eds., *Politics and Aesthetics in the Arts* (Cambridge, England: Cambridge University Press, 2000), and I am grateful for permission to reprint those segments. The first chapter, again in a slightly different shape, was given as a paper at both the University of Central England (1997) and Southampton University (1998). The chapter on Glenn Gould has been given as a paper twice: at the University of Geneva in 1997 and at Dulwich College in 1998. I am grateful to the audiences on all

those occasions for their perceptive comments and to the following individuals, who were kind enough to invite me to speak: Jonathan Arac, University of Pittsburgh; Isobel Armstrong, Birckbeck College, London; Gavin Budge, University of Central England; Wlad Godzich, University of Geneva; Paul Hamilton, Oxford University; Peter Hughes, University of Zurich; Cora Kaplan and Stephen Bygrave, Southampton University; Jan Piggott, Dulwich College; and Chris Prendergast, University of Copenhagen.

Once the various chapters had come together, the book had its first full outing during the Lent term 1998, when I gave a series of lectures to the Faculty of English in Cambridge under the title "Art's Wonder." I am especially grateful to the audience on those occasions, since this was the first opportunity I had to air the full range of my argument.

Much of the theoretical basis for the book was worked out in the company of my colleagues in a research project entitled "Unofficial Knowledge" during the years 1992–1997, although neither they nor I knew it at the time. Much of the most stimulating and enjoyably creative discussion I can recall ever having was occasioned by our meetings, and I would like to thank Jonathan Burt, Maud Ellmann, John Forrester, and Simon Goldhill for their unfailing (and perhaps unusual) generosity in participating in a truly collaborative endeavor. I would also like to thank the then Conveners of the King's College Research Centre, Martin Hyland and Alan MacFarlane, along with the then managers of the centre, for the financial and institutional support that made the project possible.

I have been extremely fortunate in having been able to ask the following people to read my manuscript in its various stages of completion: Jonathan Burt, John Butt, Maud Ellmann, John Forrester, Simon Goldhill, John Henderson, Frank Kermode, Eric Mechoulan, Ian Patterson, Greg Polletta, Chris Prendergast, David

Ward, and Rick Waswo. All of these readers helped me enormously in coming to see both the strengths and the failings of what I had done. I hope I have enhanced the former and, insofar as I am able, eradicated the latter in this published version. I would especially like to thank Greg Polletta, who read my draft with such exquisite attention and wrote at such length with so many acute observations that I wondered how much of what I had written was really mine. In any event, this finished version could not hope to repay the gift of friendship I have readily accepted.

Lindsay Waters at the Press took an early interest in my project and has been unfailingly supportive during the long march toward publication.

The book is dedicated to two people who have helped me, in their different ways, come to understand why I became interested in wonder. I can still recall a five-year-old's first excitement at seeing the collections of the National Gallery in London and the patience of my guide at the time, my mother. Not quite twenty years later Christine Adams, unknown to either her or myself at the time, began to call this book forth through her gentle but persistent inquiries as to what I was up to in my reading, looking, and listening. As things turned out, now twenty or so years after that, she continues to call this book forth in ways only she can know.

Contents

Illustrations

Art Matters

1

Introduction: Aesthetic Experience

OVER THE COURSE OF FIVE MONTHS, the young British artist Marc Quinn had nine pints of blood removed from his body in order to make the sculpture *Self* (Figure 1; frontispiece), now held in the Saatchi Collection, North London. This blood, the total amount contained in the human body, was poured into a cast of the artist's head made from dental plaster and then frozen. To preserve its solidified form, the resulting cast is housed in a refrigeration cabinet that keeps the blood at a constant temperature of minus six degrees. As Figure 2 makes clear, a thin film of ice covers the surface of the sculpture, revealing distinct signs of its fragility in the form of cracks that are beginning to expose what lies below the surface of the cast, which is of course only more frozen blood. The head is encased in a perspex cube in order to preserve the temperature within, and it sits on top of a stainless steel plinth containing the refrigeration unit. It is presented at about shoulder height; the mouth and eyes are closed, and it is difficult to tell if the

features indicate something like repose—as if the artist's senses are directed inwardly, attending to the sound or noise of consciousness (or apprehension), as if an attempt to close out the world from consciousness may fail. The sculpture simultaneously seems to be stating: "Don't look (for fear of what might be seen)" and "Look inwardly."

Described in this manner, clinically and without any attempt to color a first impression, this sculpture might appear to be coldly intellectual. It clearly raises a number of issues concerned with life and death, the permanence or fragility of art, and the act or forms— indeed the fact—of representation. But that coldness, in part prompted by the material temperature of the sculpture, is merely a surface, an epidermis that is easily punctured, thereby allowing something else to fill the viewer, something more elemental than a process of intellectualization. This book is about that "something."

I have come across viewers who, on seeing *Self* for the first time, describe a sensation akin to tingling, a kind of spinal over-excitation, or a curious shudder—that involuntary somatic spasm referred to in common speech by the phrase "someone walking on one's grave." And for some these immediate somatic responses may quickly give way to a variety of thoughts associated with formally similar presentations of the human head or face: the death mask, waxwork, funerary sculpture, embalmed body, or anatomical model. When this happens, the frisson of the physical encounter rapidly mutates into a jumble of thoughts, as if an impulse—call it a spark of affect—sets in motion a series of reactions that leave their trace in whatever permeable surface they encounter. For some viewers that surface is identifiable as "emotion," for others it is more like "ratiocination." I have witnessed some people, for example, blush on first encountering the sculpture; others turn away with a blank expression. For me the experience lies in a register for which Wordsworth had a form of words—

he characterized this state of thinking-feeling as having "thoughts that lie too deep for tears"—for I can identify an involuntary somatic impulse to weep that is nevertheless stifled by the almost equally involuntary habit of intellectualization. Much as one might stifle a yawn, thought here stifles the outward demonstration of emotion.

This state of "in-between-ness," as it were, part physical and part mental, in the orbit of the emotive yet also clearly articulated or potentially articulatable within the higher orders of mental activity, is one way of describing wonder. In the course of this book I will propose some slightly different ways, but the aim or object in view remains constant throughout. Put simply, my task is to arrive at a better understanding of what it is to be moved profoundly by a work of art. For reasons I will set out below, I have attempted this by working through three examples, three experiences or encounters with three works, each taken from different media. I call such experiences "affective" or "aesthetic," and the greater part of my discussion will be concerned with the elaboration of specific affective responses. These elaborations, however, take place both within a general set of beliefs about the nature of such responses, and within a specific context provided by the general topic of the book: art's wonder. The reasons for writing this book are deeply embedded in my desire to understand more about the practice of wondering or the poetics of wonderment. My curiosity in this regard was prompted by recognition of a common feature in my initial encounters— spread over some twenty-five years—with the three works presented in the main body of the text. I call that feature "mutism": being struck dumb.

Within the long tradition of aesthetic inquiry this state of inarticulacy has had varied fortunes: some writers have singled it out as *the* distinctive aspect of aesthetic experience. Others have relegated it to a sideline on account of a number of other issues that, according to

these writers, ought to take center stage in any discussion of art and aesthetics. I will have more to say about the various arguments around this issue below, but for the moment I would like to stay with my initial observation. I believe this "mutism," the sense of running out of words or not knowing how or where to begin speaking in the face of the artwork, to be the most common initial response to works of art (and there is, accordingly, no great originality in noticing this). Almost as common is the sense that any attempt at verbalizing a response to an artwork diminishes the experience or even destroys it. Indeed, I have encountered students who refuse to talk about their responses for fear of losing something very valuable to them (it should be said that this fear may also be based in the rather more mundane mechanics of the Cambridge supervision system). A reason for this "mutism" is sometimes given within the technical literature on aesthetics: since, it is claimed, affective experiences do not lie within the realm of the cognitive, there is nothing, as it were, to communicate. The only language that might be appropriate is that of interjection or exclamation—the ah! of surprise. This observation is also sometimes connected to a theoretical elaboration of the concept of art. According to this way of seeing things, the very definition of art is tied to this inarticulacy.

But what if this were not the case? What if this "mutism" were *merely* the result of a fault in our language—the lack of a lexicon for dealing with such experiences—and not a constitutive aspect of art as a category? Although the observation that we have very few words, hardly any at all, for talking about *affective* experiences certainly seems accurate, it does not follow that such a lexicon is beyond invention. While it may be true to say that this aspect of aesthetic inquiry has been ignored (for reasons I will outline below) even though various writers have intermittently called attention to this particular feature of encounters with art, it should not be taken as

self-evident that the attempt to construct a more supple and subtle lexicon will inevitably fail. Indeed, this book should be understood as an invitation to join forces in addressing this lack. I am keenly aware that for some people this invitation, attractive as it may or may not seem, cannot be responded to without a great deal of further elaboration, given that it is grounded on a large number of assumptions that, again for some, may be highly suspect. At the very least such assumptions need to be brought into the light of day.

What is an aesthetic experience? How might one set things up in a such a way as to have this kind of experience? Would one be able to recognize it as distinct from other kinds of experience? What would such an experience be *of*? What might keep it in the realm of the aesthetic, or allow it to be open to (or alternatively close it off from) other registers or forms of experience? And, assuming that one might be able to settle all these questions, is this form of experience communicable to myself or to others? Much of the rest of this book is an attempt to answer this last question through the force of example.

My first question, however, in part asks about the particular sense of the qualifier "aesthetic." The difficulties here derive from the fact that the word is used in a variety of ways (often for different purposes or ends and without those purposes or ends being made clear). In common speech one may, for example, speak of X's "aesthetic" as if such a thing were the distinct property of an individual. What is meant here is something like one's "taste," but the contingent and individual aspects of that term are muted in deference to the universal pretensions of the category "aesthetic." When the term is used with respect to an artist it is usually taken to refer to something like the artist's principles or particular program of making art. The term also has currency in the history of philosophy or ideas; in this context philosophers and intellectual historians speak of a tradition of "aesthetics" that began, so the story is often told, in the eighteenth

century with Baumgarten's coining of the word itself (where the der-
ivation from the Greek, meaning "sense perception," is uppermost
in its use). Although there are different accounts of this tradition and
it may be contextualized in varying ways, most would agree with the
observation that it is focused not on the single topic of "art," under-
stood either in relation to "the question of art," that is, what makes
one thing an artwork and another not, nor on the peculiar properties
that artworks may be taken to contain (often referred to as "aesthetic
properties"). Nor is this tradition solely dedicated to a discussion or
analysis of the specific forms of experience aroused by our encounter
with artworks (Kant, for example, is famously as interested in natural
forms of beauty as those that are man-made). We find, for example,
space given over to the connections between aesthetics and other
forms of judgment, such as ethics, or to the dtailed discussion of the
relationships among the various fine arts.

Yet another use of the term "aesthetics" can be found in profes-
sional philosophy, where it is sometimes used interchangeably with
the phrase "philosophy of art." But even here there are shades of
meaning or differences in emphasis. Within the branch of contem-
porary philosophy engaged with the arts that is allied with the ana-
lytic school—known as analytic aesthetics—one finds questions like,
"What is art?" "What is it to understand an artwork?" "What is the
value of art?" Here the word "aesthetics" is most often taken to refer
to a theory of art, since the primary objective of inquiry is the delin-
eation of the necessary and sufficient conditions for something to be
regarded as a work of art. But there are some philosophers who
regard the question "What is art?" as badly formulated, or unanswer-
able, or of no interest. For these writers the "question of art" cannot
be understood in isolation; it only makes sense when seen in relation
to aesthetic experience because the only way we might know what an

artwork may be is through a specific kind of experience (called "aesthetic"). For so-called aesthetic theorists of art there is, then, a distinct difference between a "theory of art" and a "theory of aesthetics"; indeed, the former is dependent upon the latter. Philosophers who take this view see art as a vehicle for aesthetic experience, and they typically formulate questions like, "What raises the sensation of beauty?" Or "Are there specific qualities that inhere in beautiful objects that arouse such responses?"

In another domain of contemporary inquiry—now standardly referred to as "theory"—"the aesthetic" most often refers to *a theory of aesthetics* whose most important thinker is generally assumed to be Immanuel Kant. But matters are equally complicated here by the lack of consensus regarding the term "aesthetics": for some writers Kant's very precise articulation of the difference between determinant and aesthetic judgment is taken to provide a definition of "aesthetics." Other theorists work within the post-Kantian tradition in which the term gains a broader set of senses. This is further complicated by the subsequent "back formation" of the term, whereby the later uses are read back into what is standardly taken to be the founding text for the entire discussion, namely, the *Critique of Judgment*. Thus in some hands a "theory of aesthetics" is taken to be completely independent of any instances of art. Theory in this guise is uninterested in the specific works of art for which a "theory of aesthetics" might initially have been thought to be useful. In its place one finds accounts of the concept's historicity (that is, its origin in a particular concatenation of Enlightenment discourses on the sublime, taste, moral sense theory, rhetoric, the fine arts, economics, and the public sphere), and this historical dimension is often taken to be decisive with respect to the notion that there might be a "pure" realm of "the aesthetic" unencumbered by history or ideology.

According to this way of thinking, the category "art" can only be understood in relation to the prior concept of "the aesthetic": "artworks" only become visible once one has a fully formed concept of "the aesthetic." As a result, the category "art" must be equally contaminated by the ideological interests of the historical formation of the concept "te aesthetic." Thus, it is held, there can be no world of the artwork that is cut free from the impurities of the historicity of "the aesthetic," since one needs the latter category in order to identify the former. In some accounts this observation is extended into a general proposition about the nature of artworks, namely, their grounding in the ideologies framing the concept of "the aesthetic." In popular terms this frequently gets transformed into the statement that artworks are merely ideology in disguise. I will have something to say about this understanding of the relationship between "art" and "the aesthetic" below.

Although I began by stating that the aim of this book is to inquire into affective experience, in the discussion so far the terms "aesthetic" and "affective" have tended to slide into each other as if they might be used interchangeably. Common speech has it that "affective" experiences include those aroused by artworks but are not defined exclusively in relation to such objects, which is to say that one's "affective" life is commonly thought of as comprising more than just the "aesthetic": emotions and our emotional lives are based in a much wider range of experiences. Throughout this book, however, when I refer to affective responses or experiences I mean to call to mind only responses *to art* (though I do not mean to imply by this that other kinds of affective response are to be denigrated). These encounters are, in the strict sense I will give the term, aesthetic, and so I will also refer to them as *aesthetic* experiences, with the italics signaling that I am using the word in this restricted way. This slightly clumsy procedure is necessary because, as I have pointed out, the

word "aesthetic(s)" is used to refer to a range of phenomena and is attached to a number of different theoretical and conceptual projects.

What distinguishes affective or *aesthetic* experiences from others is the fact that they are occasioned by encounters with artworks. This proposes a mutual definition, so that what elicits *aesthetic* experience is an artwork and an artwork is defined as an object that produces *aesthetic* experience. This mutuality is sometimes taken to be damaging for an argument—so-called circular reasoning—but it need not be. Many arguments depend upon feedback in order to gain greater clarity with respect to their initial premises. The decisive criterion here is what epistemologists call "evidential priority." In the case at hand what prompts the definition is the evidence of an aesthetic encounter: this comes first both logically and temporally, and it is only subsequent to the experience that I find it necessary to reach for a concept of "art" that might enable me to understand it. This, of course, begs the question what "the evidence of experience" might consist in, something to which I will return below.

It can fairly be said that this is not a particularly helpful way of approaching the *definition* of the concept of "art," and a number of philosophers have pointed out the problematic nature of proceeding toward a definition of art in this way (and in this instance the argument *is* circular). Furthermore, some writers would claim that affective experiences of artworks cannot take place if one lacks a definition of the general concept of "art," but I take this to demonstrate bad faith in the project launched by Immanuel Kant in his Third Critique, which precisely sets out to account for how we come to have understanding of those things for which there are no *a priori* concepts. This is to say that Kant's starting point was that some things—call them works of art—cannot be understood by moving from a general concept to a particular instance of the concept, and

his solution to the problem he set himself was to make a distinction between what he called "determinant judgment" (which does move from a general concept to its instantiation) and "aesthetical judgment." Although the latter has a number of features, at this stage I will call to mind just two: aesthetical judgments are *both* subjective and universal.

In noting that such judgments are subjective, Kant did not mean to imply that they are necessarily *individual*, given that many people may share a judgment that is, in each and every case, based upon similar grounds (that is, a *subjective* judgment may be a common property and remain subjective to each agent making the judgment). In claiming that they are universal, Kant pointed to the fact that such judgments are necessitated by our belonging to a community. It is this peculiar amalgam, the subjective that also produces an illusion of objectivity, that distinguishes the aesthetic (later I will talk about this as a "virtual effect" of an affective response). There are problems, however, with this terminology; most pressingly, "judgment," according to its normal English usage, implies a sense of discrimination, of value. Hence when it is used about artworks the evaluative sense seems always to intrude. But judgment in the Kantian sense also refers to the way we negotiate between understanding and reason. Its work is concerned with how we come to know things without any sense of value intruding. The problem arises because in English when we talk about "aesthetic judgment" what most people mean is the evaluation of something in aesthetic terms or on the grounds of aesthetics. Yet it may also be used to refer to something like "aesthetic *perception*," and in this case the second of Kant's senses seems to be uppermost in its use. In order to avoid confusion, I have used the term "judgment" exclusively in its discriminatory sense throughout this book. Nevertheless, I do wish to preserve the peculiar feature identified by Kant—the subjective but universal quality of aesthetic

judgment—in my account of *aesthetic* experience. In other words, what Kant says about "aesthetic judgment" I take as governing the definition for my use of the term *aesthetic*.

If we return to the example of art we can see how this Kantian formulation helps us make sense of the bewildering fecundity of artistic practice. According to this way of seeing things, there is no general concept of "art" that we must first formulate before we can make sense of specific examples of the category, that is, individual artworks. The consequence of this is a lack of predictive criteria that enable one to distinguish between artworks and non-artworks. In the philosopher Morris Weitz's term, art is an "open concept"—it must accommodate the permanent possibility of change, expansion, or novelty. Thus if one gives up the obsession with the need to answer the question "What is art?"—that is, the insistence that the concept of "art" be a *prerequisite* for affective experience—one is able to see that art is allowed an extraordinary diversity in form, structure, and representational content. And this includes its own self-interrogation. Moreover, the possibility presents itself that works of art may appear in forms or structures that heretofore had not been used in the creation of artworks and, furthermore, may include representational content that, at other times and in other circumstances, may have been deemed improper for or beyond the reach of artistic expression. In fairness it must be said that the notion of art's being an "open concept" does not satisfy all philosophers, some of whom continue to hold to the view that if the category "art" is to have conceptual coherence it must be able to distinguish artworks from non-artworks. And for these writers the resort to experience is built upon shaky foundations.

In contrast to this search for a precise definition of art as a prerequisite for talking about our aesthetic experience, I will argue throughout this book that the most helpful place to begin is with that

experience (even if it may well not be the best place to start a discussion of the concept of "art"). Of course such experiences are enveloped in the world, in the social, political, and ideological practices that constitute our formation as individuals. But this does not alter the fact that I have experiences of the kind I will describe. I grant that it is open to me to resist these qualitatively different experiences, indeed it is possible to set about preventing them from occurring should I believe that such experiences are merely maskings of the ideology of the aesthetic *and no more*; should I believe, in effect, that they are merely repetitions of the founding ideology of the concept of "art." But I do not believe this. I believe something very different, namely, that these moments of *aesthetic* experience (which occur far less frequently than might be supposed) are qualitatively distinct from other kinds of experience. And what makes them so is precisely their *aesthetic* nature. Such experiences do not, necessarily, come easily; they may not be available on demand. We have to work toward them, and as will become clear, work them through. We may not even recognize them when they occur or, more commonly, not know what to do with them.

It is certainly the case that I may learn from these experiences—intense moments of *aesthetic* experience feel as if they are in the orbit of knowing, as if something has been barely whispered yet somehow heard. Yet what I learn nevertheless needs to be carefully and patiently teased out of the experience (and may, for example, only become known to me after repeated exposure to the object that occasions the experience, or even at a time long after the experience itself). One way of putting this is to note that these experiences often may help me to identify what it is I already know but have yet to figure to myself as knowledge. They point toward the limit of my knowing *that*, make visible what is unknown or unknowable. And when this happens I project into the object this unknown or unknowable

knowledge: I sense the artwork as containing something I strive to uncover or appropriate. These forms of experience make *this* known to me, so in a very simple sense they can be said to have a cognitive value, but they are also much more complexly and indirectly connected to the structures of cognition.

Consequently, according to this way of seeing things, any artwork (defined as that which gives rise to an *aesthetic* response) causes us to consider the precise nature of the *aesthetic* experience it occasions. To greater or lesser extents, therefore, all encounters with art demand an answer to the question, "What is the nature of (this) *aesthetic* experience?" I shall ask this question—albeit in slightly different ways—in each of the following chapters. This does not mean that all encounters with art are *aesthetic*; nor does it imply that *aesthetic* encounters are necessarily better, more valuable, useful, or pleasurable than any others. Responses to a painting, say, may be political or economic; aspects of its presentation—say, its depiction of a narrative or its social meanings—may be exclusively attended to. But these kinds of response are not *aesthetic* in the strictest sense, and they are not, therefore, responses to the "art" component of the object (since that is defined in terms of the *aesthetic* response it elicits). Artworks have effects in the world at large, they encode or produce meanings, function as tokens or counters in an economics of exchange. From time to time they become the site of intense conflict over cultural value. These and other aspects of the objects we call artworks will, at different times and for different purposes, be deemed to be as important as *aesthetic* responses. Such non-aesthetic considerations of art have been at the center of much academic writing over the last thirty or so years. Although, to be fair, it is true to say that some writers *have* taken as their topic the nature, forms—shapes or contours—of *aesthetic* response (they include Maurice Merleau-Ponty, Mikel Dufrenne, Theodor Adorno, Hans

Georg Gadamer, Gérard Genette, and Richard Shusterman), it still remains the case that for many if not most people a certain embarrassment is associated with ou attempts to break in upon the affective moment. And this is so even when such moments are profoundly felt, cherished, and often understood to be formative with respect to an individual's development. Such qualities may, of course, help explain our reluctance to examine in any great detail the nature of our affective lives: we may prefer to keep such moments private. Be that as it may, I believe there is another reason for this underdevelopment, namely, the difficulty in identifying the distinctiveness of *aesthetic experience* (and this is equivalent to saying the difficulty of "having" *aesthetic* experience). Part of this difficulty lies precisely in the complexities of the concept of "experience" itself.

Do we "have" an experience, or, as some writers would claim, do we also (or only) "make" experience? If this is a tenable distinction, are those experiences we make more available to us, more obviously and unproblematically ours, owned by us, and perhaps consequently more deeply felt than those we have? I am not sure that the form of these questions is fully intelligible because in a slightly odd way it seems to me that we never "experience" anything in the sense of having an unmediated contact with something else. Experience is both *nachträglich*, known to us after the fact, and contaminated by the myriad filters through which we perceive and come to understand both the world and ourselves. This means that I cannot unreflectively count on experience as evidence—one of the primary topics for the poem discussed in Chapter 4—except in the restricted and special case of evidence for experience, evidence that one has had (an) experience.

If this is true of experience in general, what can be said of *aesthetic* experience? In the first instance, I do not think that the grammar of

this term, or of the concept, allows one to say either that one "has" such experiences or that one "makes" them. It makes more sense to speak of *aesthetic* experience as something to be *lived through*, not as something one might own, as one's own property, or as something created by the perceiving subject. The experience comes over one, which makes it no less tangible than any other kind of experience; it has a duration, a form, or a shape that remains knowable only to me, yet at the same time binds me to a community. The peculiar quality of the *aesthetic* is precisely its production of a virtual effect whereby something based entirely within the individual experiencing agent (its subjective basis) takes on the illusory quality of objectivity—of being both necessary and universal. Nevertheless, it is a mistake to conclude from this that we cannot talk about such experiences—to adopt a Wittgensteinian *aperçu:* saying that I cannot think another's thought is like saying that I cannot wear another's glove—or compare and contrast them, or even evaluate them. The rest of this book attempts to demonstrate how one might begin doing just this. In my view the great value of art lies in its power to prompt us to share experiences, worlds, beliefs, and differences. And our *affective* experiences of art provide a terrain upon which these singular worlds, beliefs, and differences may be mapped.

I am aware that according to some the turn toward *affective* experience is impossible because they hold to the opposite of the view I proposed above about non-aesthetic responses to art. They adhere to the belief that the affective or *aesthetic* cannot be extracted from politics or ideology: artworks are inescapably caught up in the web of their worldliness. Although I would agree with this diagnostic, I do not draw the same conclusion. Because the objects we call artworks are in the world, and, equally, since our experience of such objects is also of the world, mired in the political, social, economic, and so

forth, it does not necessarily follow that we can *only* attend to their worldliness. We may choose to see an object through different optics (often the better to see its full dimensions, qualities, and powers) while recognizing that such views are only ever partial. And we may, at different times and for different reasons, deliberately resist one or another optic, or use a sequence of different optics in order to counter the partiality of any one view. Equally we may *only* be able to see through a particular lens no matter how hard we try to see differently. The following chapters set out to perceive three works pretty much exclusively through the optic of the *aesthetic* partly because I have found, in myself as much as in others, what might be called a general lack of practice in articulating an affective response. But also because I wish to investigate in slightly greater depth the sense of wonder with which I began.

Something like this lack of practice was noted as long ago as 1929 by I. A. Richards in terms that recall my opening remarks. In his book *Practical Criticism* he observes that we have a full armory at our disposal for talking about, describing, and analyzing the sense or meaning of poetry. With respect to our affective response to a poem, however, we are not so well equipped; as he remarks:

> For handling feeling we have nothing at all comparable. We have to rely upon introspection, a few clumsy descriptive names for emotions, some scores of aesthetic adjectives and the indirect resources of poetry, resources at the disposal of a few men only, and for them only in exceptional hours. Introspection has become a byword, even where intellectual and sensory products and processes are concerned, but it is even more untrustworthy when applied to feelings. For a feeling even more than an idea or an image tends to vanish as we turn our attention upon it. We have to catch it by the tip of

its tail as it decamps. Furthermore, even when we are par-
tially successful in catching it, we do not yet know how to
analyse it.[1]

The chapters that follow begin this task of mapping out an *affec-
tive* response to artworks by pressing hard on the lexicon of emotion
or feeling, a lexicon that is underused in most academic discussions
of art. By "pressing hard" I mean to suggest what I hope will be rec-
ognized as a refusal to give over my exploration of *aesthetic* experi-
ence to an inarticulate or inarticulable feeling; still less to an
unreflective or "emotive" response. The history of literary criticism
certainly includes both "harder" and "softer" versions of the emotive,
as do commentaries and appreciations of the other fine arts. Indeed,
a particular form of this line of inquiry, known as "personal criti-
cism," has recently emerged in academic discussion of literature and
the arts more generally, but this book is not intended as a contribu-
tion to that discussion. Although I start from what I can identify as a
"feeling," this merely provides a basis for further elaboration and
speculation; it is certainly not an end point or resting place for the
encounters presented here. In proceeding this way, a map or archi-
tecture of my experience will begin to emerge, and what I take to be
the specifically *aesthetic* aspects of my responses will become more
evident. It is on the basis of the descriptions of these responses that a
discriminatory evaluation of artworks becomes possible: if my
response to a particular work is uniform, monotonous, weakly felt, or
trivial I feel confident in assigning to it a lower *aesthetic value* than
to one that elicits a varied, sustained, polyphonic, or deeply felt
response.

In making this criterion the basis of such evaluative judgments, I
am equating the *aesthetic* value of the work with the quality of the
response it generates. I am happy to make this connection because I

believe that the "art" in an artwork, the specific element of the object that can be understood as its *aesthetic* aspect, is only knowable to us in our response. In effect, the response is equivalent to the materiality of the artwork; it is identical to what we might identify as the "art" component of an artwork. Nonetheless, this view makes room for the fact that an equally valid response to an artwork may come wrapped up in our attending to other components of its materiality—say, its political or ideological motivations, meanings, or effects. It is for this reason that I find attempts to define particular qualities of those objects designated artworks as "aesthetic" qualities—harmony, unity, intensity, and so on—unhelpful because they suggest that one's attention should be directed at the artwork rather than at an experience of it. This slippage or sliding away from what I take to be the proper object of attention confuses the location of the "art" component because that "art" is uniquely a feature of an *aesthetic* experience and not something within the object; although the tools we need to locate and understand that experience may *appear to the viewer* to reside in the object, this appearance is an illusion produced by our *affective* response. Having said this, I do, nevertheless, recognize that one way of getting to a response is to direct attention to the formal properties of the object—harmony, unity, and so forth—but it should be noted that this is a stage in a process, a means toward the aim of living through the *aesthetic* experience. I will address this topic in greater detail in Chapter 3.

If the "art" component of a work can properly be said to be a function of an *aesthetic* encounter with it, then it follows that any object may be deemed to be an "artwork" since, as mentioned, the quality of being "art" lies not, in any sense susceptible of description or analysis, in the object but in the response it elicits. This observation is sometimes, and wrongly in my view, taken to underwrite the notion that since anything can be art then everything is as good as

everything else. Discrimination between artworks is, according to this line of argument, merely the spume kicked up by competing tastes, obsessions, and prejudices. Yet *aesthetic* value is determined by the quality of response: if a particular object arouses the kind of response one can recognize as "strong" or "deep," then it has claims on a high *aesthetic* value no matter how simple, trivial, or roughly worked up the object itself may be. But in order to know how strong the response is, one needs to be able to articulate it—to oneself as much as to others. This is why we need to turn our attention toward the sensation of "mutism." It will undoubtedly be remarked that "strength" and "depth" are mobile qualifiers: my strong is someone else's weak; what seems original to me may be clichéd to another. This is correct but also inevitable given what I have said about the nature of *aesthetic* experiences—that is, the fact that they are *both* subjective and universal. They come in the form "what is strong for me *must* be strong for you." But matters do not rest here—if they do, we have progressed no distance at all in understanding the unusual value of *aesthetic* experiences—since it is now incumbent upon me to explain how such experiences may be strong, trivial, or something else. In the process a sense of commonality emerges, of shared experience created when we map ourdifferences, and these will certainly include the distinctions of culture, background, training, education, and expertise, onto what feels like mutual terrain: the affective experience that gives rise to our making evaluative judgments of artworks.

Any affective encounter with an artwork, therefore, necessarily involves discrimination between different encounters, different objects. It also follows that some artworks appear to us to be better than others. Hence the need to elaborate the criteria used in making such evaluative judgments. In recent years some commentators on the aesthetic have felt uncomfortable with the evaluative aspect of encounters with art and have sought to ground the criteria for

judgment exclusively in non-aesthetic aspects of the work or its context (and this, to some extent, erases the unique value of art). Others have sought refuge in a number of "humanist" positions that are not exclusively features of artworks but that, nevertheless, are taken to underwrite the value of art in general. These two positions have been set against each other for more than twenty years in what many now regard as a dialogue of the deaf. At the risk of entering this peculiar vortex, I would like to state, for my own part, that I do not think enough has been said about the *aesthetic* components of the artwork, or how *aesthetic* experience leads to evaluative judgments based precisely in this distinctive form of experience. This observation leaves untouched the correct analysis of the contingent nature of non-aesthetic qualities that also impinge on the work and on our non-aesthetic evaluations of it. The reason so little has been said on this matter is the "mutism" with which I began.

I have remarked above that the best way to address this problem is to turn one's attention toward specific examples of affective experience, and this will occupy the following chapters. I will first take a work of visual art, a painting by the abstract expressionist painter Barnett Newman, before moving to an example of music, the Canadian pianist Glenn Gould's second recording of J. S. Bach's *Goldberg Variations*. My final example is taken from the domain of literature: Wordsworth's poem *We Are Seven*. These three readings constitute an itinerary of sorts; they are moments within my ongoing *aesthetic* education. Although they are by no means meant to convey a historical or chronological account of that education (the last example has been known to me for the longest time by a matter of decades), they nevertheless build upon one another as ways of coming to understand better the nature of my affective experience. I began this introduction with an example that was intended to point toward a qualitative difference in my experience of the world, that is, with the

experience of being with Marc Quinn's *Self*. That experience raises in me a distinct sense or sensation of being aroused, made curious, and it is this sense or sensation I mean to highlight as a way of starting my inquiry. In the next chapter I begin with *Vir Heroicus Sublimis*, but the need to start there—in a sense or sensation—is attenuated somewhat in the third chapter, on music. There I build upon the recognition that artworks ask us to confront the issue of distance as this concept arises in the perception and reception of them. And, building on the discussion in the third chapter, the discussion of poetry in the fourth starts out from what I hope is a clearly focused account of what is distinctively *aesthetic* in my encounters with art.

Although my presentation is inevitably cumulative, it is not intended to be structurally linear, that is, each successive reading is not meant to be intelligible only in the light of the preceding chapter: Gould's *Goldberg*, for example, is not to be understood exclusively in relation to the account of Newman's *Vir Heroicus Sublimis*. On the contrary, my examples are presented as just that: discrete encounters with specific works of art, and to this extent they may be taken as free-standing accounts whose exemplarity is in part derived from their attempts to arrive at the work without baggage (something that is, of course, impossible in the final analysis). However, as I have already remarked, these encounters must also be understood as participating in my own ongoing *aesthetic* education, which necessarily gives them another dimension and asks me to read them within and against one another. I have tried to do this in my concluding remarks.

One question remains concerning the competency of those experiencing an artwork: Can one person be equally at home with romantic poetry, baroque keyboard music, and abstract painting? Without wishing to be in the least hubristic, I think it is important to note that the perception of artworks does not necessarily come easy,

as if all one has to do is open one's eyes in order to see. It may take many years of patient practice to grasp some works fully, whereas others may require specific kinds of knowledge before one can begin to attune oneself to their art. Thus, for example, it seems valid to me that one might ask what one needs to know, in a propositional sense, in order to begin appreciating a particular work. In addition, one might also need to know similar works—in the sense of having been exposed to such forms—before one is able to see, hear, or read with conviction. But the question here is, How much does one need to know? And, just as important, how much does knowing such things also block or prevent one from seeing, hearing, or reading?

Although I believe that training the eye or ear can be very helpful, I will nevertheless temper this observation by insisting throughout this book that the extent of that training, or what it might consist in, is to a great extent indicated by the work itself. Given that, as I have already said, we only come to know the work through the material of our affective experience of it, it follows that such indication in fact comes from our *aesthetic* encounter with the artwork. In other words, we can only know how much "background" or expertise, training in the ear, or whatever might be helpful with respect to any artwork by attending to our affective response. And it is certainly possible that our assessment of this may change over time or with particular circumstances. My focus, therefore, will be on specific encounters with works of art in full awareness of the fact that such encounters have a historical dimension.

2

Serenity: Barnett Newman's
Vir Heroicus Sublimis

O N JANUARY 29, 1948, the day of his fifty-third birth-
day, the New York painter Barnett Newman com-
pleted what would become his "first" painting. It measures 27″ × 16″,
is done in oil on a canvas support, and looks like an undifferentiated
rectangle of reddish brown punctuated in the center by a roughly
painted band of orange whose width is approximately one-twentieth
of the total width of the painting. Newman had, of course, painted
before this day. Indeed, he had first started to train as an artist twenty-
six years earlier, when he enrolled in the Arts Students League in
1922; nine years later, at the age of twenty-six, he had become a full-
time substitute art teacher in the New York high school system. By
1940, however, he had almost entirely ceased artistic production, and
only began to paint again some four years later. It would be another
four years before he found his "first" painting.

Immediately after completing that image on his fifty-third birth-day, he was unsure about what he had done. The canvas felt less "atmospheric" than had his previous attempts, by which he meant that it did not take anything from "external nature" as its subject. In his own words, what this as-yet-unnamed painting did was to make him "realize . . . that I was confronted for the first time with the thing that I did."[1] He was to live with the image for another eight or nine months before he figured out exactly what he had done.

Eight or nine months.

When, at the end of this intense period, he was able to see the implications of what he had made, he realized that he had been set free from the burden and constraint of picture-making. Here, in this painting he was to call *Onement I* (Figure 3), he discovered the thaumaturgy of his art.

I begin with this anecdote as a way of opening up a number of questions that can be phrased to the art of painting. As the story seeks to make clear, the knowing that is the artwork is not always instantly accessible to the artist who made it. This raises my first question: How can one prepare for art, make oneself ready to accept it? How does one prepare for the presence of painting? I phrase the question this way because the act of looking at painting requires some form of reconciliation or accommodation between the presence of the viewer—the sense one has of being here in the act of looking—and the presence announced by the painting itself. One way of approaching my question, then, would be to point to the necessity of reconciling two potentially competing statements of presence. A preparation for painting, in these terms, would amount to an acceptance of that necessity. In the discussion that follows I will elaborate on what I mean by this acceptance through a detailed examination of my experience of looking at a work of visual art. As noted, that experience is, in effect, an analogue of the material of the artwork; it

is all we ever know of the artwork as *art*, since it is *this* material, the affective response, that indicates that we are in the presence of an art-work. This materiality rarely feels as if it were a property of the view-ing subject—that is, something made from within the viewer—as one might argue it should, given that it is only brought to our aware-ness through the process of an affective experience.

Indeed, two complementary sensations moving in opposite direc-tions commonly attend the experience of visual art. On the one hand we feel as if the artwork comes upon us, ready-made, so that our sense of perceiving something out there leaves a kind of imprint within the viewing experience. Almost like a ghostly after-image. Seen in this light, the artwork might be described as a kind of trace accessible to us only in the unusual form of a photographic negative that is an affective response. On the other hand, our affective experi-ence gives us the sensation of becoming intimate with the work of art, closing the distance between it and ourselves. On occasion this feeling may become so intense that we almost identify ourselves with the work, or colonize it, appropriate it. These two trajectories of the encounter, one moving in the direction of the viewer (into the inte-rior of the viewer's affective life), the other in the direction of the object (into the inner reaches of the artwork), bear upon any affec-tive response to visual art and have effects at the material level of my *aesthetic* experience.

One might object to this particular gloss on the materiality of the artwork on the grounds that the visual arts in general occupy real space, and that the "real" material of the work—stone, wood, paint on canvas, and so on—is obviously distinct from our response to it. Painting, for example, stakes a claim to its own space, proclaims its presence in no uncertain terms. It insistently announces *its being here* and, in so doing, requires of the viewer a particular form of address to and negotiation with the persistence of its presentation.

Furthermore, the painting is a unique physical entity; its presence cannot be replicated even in the age of mechanical reproduction. This canvas, this paint, this wall, this museum, this space determine our address to any painting, and similar material considerations are operational in our responses to any work of visual art. Of course different art forms also work with the notion of specificity in diverging ways, but in the case of visual art there is something distinctive about the sheer weight of the presence that is the physical envelope of painting (or indeed sculpture). I find that weight of presence to be unavoidable and one of the things that distinguishes my responses to painting or sculpture. On account of this, my attempts to explore the affective experience of looking at a painting will attend both to the physical object—what might be termed its "real" materiality—and to the materiality of the artwork, that is, the "art" in the work, which is made accessible to me through my affective response.

Part of my argument about the value of artworks, of how we come to value some more than others, is based on the observation that the artwork itself guides us in how to approach it: the image, to some extent, teaches us how to look, the music how to listen, the poem how to read. It is this notion of the artwork *itself* intending its modes and modalities of reception and understanding that is bound up in what I wish to call the virtual effect of art, the sense we have that what is internal to our affective experience is a reflection of or response to what is "inside" the work. This we know to be a virtual effect, a by-product of an affective response, since we also know that our perception of the work's inner depths, or in the terms of philosophical aesthetics, its "intrinsic qualities," is entirely conditional upon our encounter with the work. Indeed, it is self-evident that we only become aware of what is distinctive to art at all, aware of the "art" in the artwork, through an encounter with it.

Thus while our evaluative judgments are subjective, they never-theless appear to us as grounded in and necessitated by objective qualities of the work. These objective qualities have sometimes been associated with the so-called formal properties of artworks: the iden-tification and analysis of brush stroke, the kind of pigment, the method of its application, its interaction with the support, frame, and content of the image, and so on—all may provide help in focusing on an affective response to a work. By attending to these and other formal properties, I can gain a purchase on *how* the work interacts with my affective response. Such affect is neither produced by nor contained in these or any other formal properties, for the "art" in the artwork does not lie in pigment, mode of application, vraisemblance of the image, and so forth, even though a great deal of "art" in the sense of skill may have been necessary for the production of the pic-ture. It is nevertheless the case that the virtual effect of an encounter with an artwork is the recognition of its singularity. Any affective response thus seems to have been caused by the specificity of both the object and our encounter with it.

But because this encounter is specific—to a time and place, a par-ticular cultural background, training of the eye, and so forth—it does not also imply that the works we take to be the immediate cause of our affective responses appear to us as equally bound. I am thinking here of the sense we have that the artwork in front of us is unique, transcending its contingent process of production and reception. This sense of transcendence must also be "virtual" since we know the object to be entirely contained in and produced by its specific contexts of viewing, evaluation, artistic production, and so on. But knowing this need not also prevent the affective experience from taking place. Indeed, in the cases of those works often deemed to be "great" works of art, the sense of their transcendence, of their

capacity to arouse such strong affective responses no matter what context they are placed in, whether or not the viewer is trained or comes from a similar cultural context, is often very intense. This sense of the work's transcendence is another feature of *aesthetic* encounters with artworks, and it is something we should acknowledge and investigate rather than feel awkward or embarrassed about. Michelangelo's Rondanini *Pietà*, for example, arouses in me a feeling that the work is timeless, since its beauty appears elemental, as if it constituted one of the basic building blocks of our shared culture, our common humanity. This sense of elemental beauty feels as if it were compelled by the work itself, so that it appears to me as if anyone coming into contact with it must recognize what I perceive as the work's transcendent power. In my view we can experience such works and their virtual effect of transcendence without surrendering the knowledge that any encounter with an artwork is specific to a time and place, a cultural tradition, and so forth, and that what makes one object the focus of intense scrutiny rather than another is equally determined y the contingencies of context, tradition, and cultural practice.

There are many examples of works formerly lost to a tradition of appreciation being resurrected and highly valued in a changed context of reception; there are as many works whose power, interest, genius, or transcendence can be shown to be entirely contingent upon a single moment in their reception history that may nevertheless have a significantly extended half-life (reaching down to the present of evaluation, for example). An example of the former would be Eliot's appreciation of Dante, and of the latter, eighteenth-century bardolatry. But knowing either of these things is not a prerequisite of an *aesthetic* encounter. Very often, in fact, knowledge of this kind may block or prevent an affective experience, stifle or stunt the emergence of art's low, whispering voice. The crucial thing here

is how non-aesthetic responses may enable rather than disable *aesthetic* experience.

The image that will take center stage in the rest of this chapter, Newman's *Vir Heroicus Sublimis* (Figure 4), deserves a few preliminary remarks. To begin with, the work is a "high art" painting, oil on canvas, that hangs in a veritable temple of modern art, the Museum of Modern Art in New York. Its formal genre, then, is easel painting in oil, its location for display the accredited institution of the museum—and not just any museum, but one of the most highly regarded museums in the world. It is abundantly clear that one cannot come to this image innocent of these basic frames of reference. Furthermore, both the formal genre of the image and the context of its display have histories, and such histories necessarily encode and are embedded in a variety of ideological stances vis-à-vis this kind of art (abstract, twentieth-century, American) and this type of institution (with its policies of acquisition, display, and patronage). Consequently, individual viewers will come to this image carrying their own particular responses to and versions of this ideological baggage; that is, particular viewers will have differing proclivities, differing tastes that will have been formed, to varying extents, in the crucible of their own specific viewing experiences and according to their own likes and dislikes. It would be fair to say, therefore, that one cannot just open one's eyes and "look" at the image I have chosen given that, to some extent, one's eyes are already open: the painting has, to some extent, already been "seen."

Perhaps the most common reaction to this canvas is bemusement. What does it mean, what does it represent? What is it trying to say? Even viewers familiar with abstract expressionist art, or with what has come to be known as "color field" painting, may find this canvas too resistant, too cold, too intellectual. And if this is so, bemusement may quickly be transformed into stronger negative reactions such as

disappointment, boredom, or resentment. Compared with the canvases Rothko painted from about 1950 onward, say, *Red, Brown, and Black* of 1958 (Figure 5), which also hangs in MoMA, Newman's vast painting seems to inhabit a different world, and this is so even though at first glance it would appear to share certain surface similarities with Rothko's "color field" pictures—the apparent removal of the basic building blocks of Western representational painting: drawing, unilinear perspective, composition, narrative incident, vraisemblance. Most viewers find Rothko's paintings emotionally engaging if not draining (this is certainly enhanced by knowledge of the painter's life and eventual suicide), full of warmth, passion, and above all *open* to the viewer. Although the look of these paintings is not a million miles away from Newman's canvases there is, nevertheless, a *material* difference between them. In Rothko's case the paint is applied unevenly, its density varies; the *application* of paint to canvas is still a part of its material presentation. With Newman the paint is uniform, giving the impression of a seamless join between paint and support—as if the material here were color itself. Where Rothko lets the effort of painting show through, Newman smoothes out the effortfulness of production.

None of this should necessarily diminish the one painting against the other; by noting such formal differences I am merely trying to get more precise the contrasting *registers* of response elicited by these two great artists. Rothko, at least on first acquaintance, paints for the eye, whereas Newman, again on first sight, paints for the intellect. Rothko's dense and poetic washes of color burst out with the untidiness and passion of our emotional lives, whereas Newman's clinical cuts into color speak the propositional language of abstract thought. Perhaps this is why Newman's mystically entitled paintings, sculptures, drawings, and prints seem to erect a boundary around themselves, as if we need to be in the know before we "get" the work,

understand its rhythms, enter into its imaginative world, feel the intensity of its presentation. In a curious way Newman's canvases require us to learn how to become comfortable with the notion that we must move from an initial blindness in the face of this art toward insight. We must work with our "mutism," not against it.

But beginning in this way is an error. As the best critics of Newman have noted, the questions I have just raised—what does it mean, represent, what is it trying to say?—are the wrong questions to ask of his painting. One is better off taking the lead provided by Harold Rosenberg in a *New Yorker* article of 1972: "No one of his paintings stands for anything definite: it is not a symbol or an emblem, any more than it is pictorial."[2] Thus, the more useful point of departure would be, "How does this painting determine my address to it, and in so doing, what does that address do, for me and for the painting?" Having asked this preliminary question, the follow-up might be, "How does it make me feel, what does it make me feel? What is the content of my affective response?" Beyond these questions there lies the insistent murmur of all great art, the nagging thought that the work holds something to itself, contains something that in the final analysis remains untouchable, unknowable. Hence the question that will quietly but insistently insinuate itself into the following speculations: What does this painting know?

THE FIRST AND MOST OBVIOUS feature that determines an address to this image is its size. The limitations upon the size of oil painting on canvas have been known for a very long time. The difficulty of stretching canvas across many feet, painting the surface from physically uncomfortable positions, maneuvering the finished painting, and finding suitable locations for its eventual display—these problems were known to the early-nineteenth-century

American painters of the sublime, English painters in the grand manner during the eighteenth century, artists attached to the European courts of the sixteenth and seventeenth centuries, and, before them all, to the quattrocento masters who gave the Western tradition of representational painting so much of its language. But size, as they say, is not everything. Size only gives us hints in relation to the aura of presentation. It is, nevertheless, a good place to begin with *Vir Heroicus Sublimis* since it is one of the most obvious, and obviously noticeable, features of the painting. The canvas measures 7 feet 11 3/8 inches by 17 feet 9 1/4 inches. If the average person's stride is around three feet, it takes five full strides to traverse the image. I think this tells us something about the optical regime constructed and required by this image. Size, then, is one of the first things we encounter; it frames our approach to the image.

The next most obvious thing about the painting is that it is empty of representational content; the image is "abstract," which is to say that it does not *depict* anything except, perhaps, color. If the primary concern of the Western tradition of painterly representation can be said to be the mirroring or re-presentation of the world, then this canvas has, at least at first glance, erased all trace of that tradition, painted it out. There are no conventional marks organized according to the systems of drawing evolved over centuries of Western art that seek to depict the world as we see it. And not only has the world in the sense of the objects that surround us been "abstracted" away, but so has the human figure. Perhaps this is why many first reactions to the painting find it cold, almost inhuman, perhaps inhumane.

By the time Newman painted the canvas in 1950, such abstraction or turning away from the figurative was hardly a novelty: in the wake of cubism's experiments of crazy-paving Western representational pictorial conventions, artists such as Delaunay, Leger, and perhaps

above all Mondrian had begun, in the second decade of the twenti-
eth century, to create canvases that contained no more than design
and color. It could be said that the images created by these and other
artists contained more incident than Newman's rectangle of red, and
that they were on a much smaller scale, but the emptying out of rep-
resentational content is there for all to behold. Within the history of
art this voyage into abstraction is frequently discussed in terms of a
narrative trajectory toward minimalism: first the standard forms of
conventional representation are skewed, then all pretence to "repre-
sentation" itself is dropped. Subsequently, the very building blocks
of painting begin to be investigated in their own right: design, brush
stroke, color, texture, the grain of the surface of the support, pig-
ment, frame, location for hanging, and so on. Once all these and the
myriad other material bases of painting have been subjected to
intense scrutiny and continuous experimentation, one ends up with
the blank canvas or the immaterial artwork, and conceptualism has
arrived. Newman's canvases are often slotted into this narrative along
with the paintings of what Robert Hughes calls the "theological"
wing of the New York School, and in Hughes's dismissive judgment
they appear "abolitionist, fierce, and mute."[3]

As is well known, Newman himself made all sorts of claims for the
art he and his fellow abstract expressionist painters created, but these
claims, interesting as they are in relation to a cultural history of mod-
ern painting, are nothing in comparison with the claims made by the
painting itself. Hughes remains deaf to such claims; he has been dis-
tracted by the sometimes grandiose statements of the artists and the
critical ballast supplied by supportive commentators. While it would
seem perverse to ignore these statements completely—especially
Newman's own account of his artistic practice (and I will not do
so)—it nevertheless remains the case that these discursive claims

must be weighed against the images themselves. For Hughes and other critics of Newman's work, the singular attention to the pronouncements of the artist render the canvases inert; they divert attention away from the peculiarities of being with these images and block our reception of their majestic frequencies. If, however, we attempt to look *with* these intensely painterly works, we will begin to see just how far out Hughes's characterization of Newman's art is.

"Abolitionist" is how Hughes first brands Newman's painting. I take this to say that it abolishes the standard conventions of Western representational art. It strips out the objects of the world, erases the human form. There's nothing left but color and the occasional punctuation of color in the vertical stripes—"zips," as Newman called them—that are the painter's signature. Perhaps for Hughes what makes them "fierce" as well as "mute" is the fact that they would seem to offer no easy route into their pictorial space or imaginative world: some might say, erroneously, in my view, that they approach the zero ground of representation itself. As noted, this way of looking at Newman's work gains currency from one of the predominant narratives of twentieth-century Western art that sees a singular trajectory toward minimalism (and beyond). But for reasons I will explore below, this places these paintings in the wrong company, situates them in a misleading narrative, frames them on shaky grounds.

Technical considerations are not the only reasons for the size of painted canvases; indeed, there are other, more obviously pictorial and optical reasons as well. One, for example, is the use to which a painting is put; while this is so obvious as to be almost banal, I want to begin here because use tells us something about the ways in which this canvas intersects with those regimes of looking that bore upon the original context of production and reception. A canvas may measure two feet by three feet because it was painted to hang in

a private room, say, and to be looked at in the company of particular individuals—family or close friends—at certain times and in a certain way. Such regimes of looking, by which I mean to refer to the fuller context for looking at representations, are not particularly numerous. Indeed, from the evidence of the Western tradition one might note four principal regimes: the devotional, awe-inspiring, self-aggrandizing, and proprietorial, which correspond (although not precisely or without remainder) to four distinct genres of painting—the sacred, history, allegory, and portrait. All four regimes, however, share a common set of optical assumptions about the position of the viewer in relation to the canvas that is most readily conveyed in the conventions of unilinear perspective. Those assumptions bear upon the status of the viewer and both construct and reflect, albeit in differing ways, the subject who views. In other words, though different genres of painting may—especially over long historical periods—demand and help construct quite distinct forms for the viewing subject (and therefore inflect subjectivity itself in sometimes markedly different ways), these different regimes of looking are nonetheless based upon a common conceptualization of the relationship between the viewer and the canvas. The canvas occupies a single space, the plane of representation, while the viewer is situated at what unilinear perspective determines as the "true point of sight." While the subject who comes to the view may be defined in different ways and take up different attitudes to the image—this is most obviously demonstrated by the distances between the devotional and the proprietorial—it nevertheless remains the case that the spatial relationships constructed in the practice of viewing are common to all four regimes.

Different subjects with different expectations, aims, and objectives enter into the same optical circuits set in motion by the predominant pictorial traditions of Western art. And these spatial relationships between the subject-who-looks and the plane of representation

intensify the sense the viewer has of his or her own subjectivity at least *as much as* the representational content of the image. The resulting practice of looking can best be described as identification—I am in that world, the world of this image is mine—and this is so whether or not the image contains the conventional marks of figurative representation. Here it is useful to note that figurative painting is merely one way, albeit the predominant one in the Western tradition, of imaging to the viewing subject his or her sense of self. Other representational modes—such as abstraction—are not excluded from this practice of identification, as I will argue below.

In the standard narrative of twentieth-century Western art, abstract painting is supposed to fracture and fragment these spatial relationships: firs, as noted above, it removes all trace of the figurative and then begins the work of reconfiguring the relationships between the point of viewing and the canvas. This reconfiguration is responsible for the fact that some viewers accustomed to representational art find abstract art "inhuman," lacking a point of entry, or, in Hughes's word, "fierce." According to a general philosophical account of the fragmentation of the modern subject, abstract art "re-presents" the alienation of the modern world, that is to say, its *content* is taken to be abstract. But this is too simplistic and unsupple, and in the case of Newman precisely the opposite is true: abstraction is merely the *formal* language in which he paints and not the representational content of the image.

The upshot of this is my belief that *Vir Heroicus Sublimis* shares the same regime of looking—the devotional—as the illustrious works of art Newman claims as his touchstones. Although size may determine our address to the canvas, it is not the physical dimension of the image that exclusively underpins our affective response. Size, in fact, is far less important than *scale*. If one compares *Vir Heroicus Sublimis* to another early canvas—*Concord* of 1949 (Figure 6)—one

can see how in Newman's own words his painting tries "to transcend the size for the sake of scale."[4] This canvas measures 89 3/4 inches × 53 5/8, yet it courts the same regime of looking as *Vir Heroicus Sublimis*, which is more than three times as wide. In 1966 in an interview with Andrew Hudson, then the art critic of the *Washington Post*, Newman remarked:

> In 1950, to test myself to see if I were really able to handle the problem of scale in all its aspects, to challenge myself against the notion that I could be beguiled by the large masses of colour, I did the very narrow one-and-a-half-inch painting. I think it holds up as well as any big one I have ever done. The issue is one of scale, and scale is a felt thing. It is not something you can build or develop by relating parts of a painting or deciding after the fact how much of the painting is the painting. The scale of a painting in the end depends on the artist's sense of space, and the more one succeeds in separating the painting from the sense of environment.[5]

The point here is that though a portrait miniature may be one-hundredth the size of a grand formal portrait, its dimensions are only tangential to its *scale*. Similarly, the gigantism of much late-twentieth-century American art that supposedly creates its dehumanizing effects does not, necessarily, go hand in hand with gigantic scale. Many works—such as Claes Oldenburg's everyday objects rendered in loving (and absurd) magnified precision, of which *Clothespin, Philadelphia* (1976) is a good example—are physically enormous but miniature in scale. Although it takes five or more strides to pass by *Vir Heroicus Sublimis*, its scale cannot be measured at the same time and in the same units of measurement. While this image is, and aspires to be, heroic, its heroism is fully in scale both with Michelangelo's *David* and with Holbein's portrait of Erasmus.

Furthermore, it conforms to the same modes and modalities of presentation as these icons of Western artistic practice; far from shattering the Western tradition's conceptualization of the practice of viewing, Newman's canvas seeks to reinforce it, make it new, perhaps, but make it all the same. A rapid glance may see nothing but red, a dismissive eye feel the assault of size; however, when one begins to explore the act of looking, lets the image lead the eye, a different sense of its scale and indeed its pictorial forebears will emerge.

This takes me back to the issue of use. What purpose lay behind the making of this art? What are the uses to which such a canvas might be put? It is significant in this regard that when Newman started to produce his "eighteen-footers" they could not be shown outside the studio for want of a commercial gallery space that could accommodate them. This says something about the space in which they can be seen, which is much more likely to be a public museum or gallery-style environment than a private residential space—although a renaissance court, for example, would have provided ample room. Perhaps one can go even further and note that the particular kind of public gallery space that might accommodate these vast paintings was more likely to resemble that of major public collections—spaces like the one in which it does hang, the Museum of Modern Art in New York—than small-scale commercial galleries. We may reasonably conclude, therefore, that this image imagines its site of viewing, location for being seen, as a public and social space. Consequently, the painting raises questions concerned with the social practice of viewing: How does one share a public space in the act of viewing art? To what extent is the viewer allowed to find or construct private spaces in front of the canvas? What degree of permeability divides the public from the private? How far or how easily may one negotiate the boundary between the two? How might this

image encourage a sense of community, of belonging to a shared space, inhabiting a communal experience?

Such questions impinge upon another issue I raised in connection with scale—the removal of the human figure from the picture plane. To my mind this removal is more like a displacement than an erasure, more a relocation in order to remake and indeed intensify the sensation of identification that results from the viewing practice I have characterized as the predominant form developed in response to Western representational painting. In effect, the depicted human form is displaced from the picture plane, only to resurface on the other side, as it were, in the space in front of the canvas. This displacement is far from unique to this painting or to abstract expressionism; we find it in an array of images from the Western tradition, albeit inflected in slightly different ways according to the type of painting, the uses to which it is put, and so forth—I think of Hogarth's images of Bedlam or, perhaps the *locus classicus*, Velasquez's *Las Meninas*. The point here is that, curiously enough, this abstract image constructs as intense a sense of presence, of the human form being presented to representation, as any painting I can think of. Given this, it can be said to *represent* the human—albeit through its displacement from the picture plane—as powerfully, or perhaps for our own point in the history of artistic practice *more* powerfully, than any figurative painting might or can.

I am, of course, aware that the opposite view is more common; that the absence of anything remotely figurative on the picture plane, coupled with the size of the image, renders it inhuman, or, to take a cue from the title, superhuman. Some critics believe that such a reaction is intensified by the viewer's physical address to the image: the canvas is so large that it throws into crisis the notion of a "proper distance" and, thereby, renders the practice of viewing uncomfortable—as if we have to move across it, away from it, up close, far away.

The resulting mobility in relation to the *distance* we gain supposedly serves to accentuate the sense of discomfort, of feeling small or ill equipped, as if the image refuses to be scaled to our own world—it seems too big for the view from here, to be held within the eye of the beholder. But I find this way of characterizing the image and its effects on the act of looking out of reach—too far away from my own viewing experience. Perhaps such attempts at describing the picture are designed to protect a particular version of the viewing subject, one in which the desire for mastery determines how the viewer enters into the optical circuits of looking. I take it that the aim of this desire is to protect the viewing subject from confronting him- or herself in the act of looking, from auto-voyeurism. In contrast to this sense of the inhuman or superhuman I find something else, more involving or inclusive, indeed social and shareable, and this is coupled with a nagging persistence of *presentation*, of being made present. For me, *Vir Heroicus Sublimis* demands that the viewer resist a particular form of looking, traverse the reflective stare of looking at oneself looking in order to enter a shared space in which the nakedness of presentation asks one to face up to being here, in the visibility of a communally constructed presence. Here in the hushed sublimity of a shared world. And this, perhaps, provides me with the first glipse of what this painting might know, or rather what its knowing might be.

I do not think that this way of addressing the image is uniquely prompted by this canvas; as noted, the regime of looking required by this painting conforms with one of the predominant regimes developed through the Western tradition of figurative painting, namely, the devotional. Thus, while *Vir Heroicus Sublimis* may picture itself as a devotional or sacred image in slightly unusual ways, it does not, nor do I think it seeks to, erase, fracture, or fragment the tradition of painting it recognizes as its prehistory. It may take the single point of

viewing, the pinhole that is the viewing subject for unilinear per-spectival representations, and elongate it, effectively transforming the pupil from a hole into surface, as if the eye were enlarged to include the cutaneous surface of the body so that this somatic enve-lope becomes sensitized to the visual. The eye, in effect, is able to see, but the optical circuits of viewing remain the same. While it may at first appear as if the viewing subject needs to occupy a series of points in front of the canvas—as if walking across it or tracing an arc from one side to the other were to plot the positions from which a series of views may be taken—this sense is dissolved once one notices the fuller somatic presencing to vision. The singularity of one point perspective has been maintained by troping the organ of sight into the entire cutaneous envelope of the body and by shorten-ing the focal point of viewing. Hence the presentation of the body to vision—and not just my body, but the somatic in general, the social body constructed in the practice of viewing in public. Because of this the viewing subject that here comprises more than one agent is no *less* present to the activity of viewing, in a sense no less human than its counterpart in front of, say, a Rembrandt self-portrait. If any-thing it is more self-present, more human. Scale, then, puts the viewer in touch with the image, helping to define the point of entry into the shared world of its ar.

WHEN VIEWING *Vir Heroicus Sublimis,* one sees pre-dominantly red. But there are punctuation marks in the field of color, the lines or stripes, what Newman called "zips," of a different color. These zips give animation to the canvas, introduce time into the look, and help temporalize the experience of viewing. In effect the zips keep time. They are both incisions into the undifferentiated expanse of red, and markers or lines laid upon its surface. They both

expose the depth of the image—cut away to the underside of the presentation, disclose what lies underneath redness—and mark the fact of or bear witness to the impenetrability of color. They punctuate the impervious surface of redness, demonstrate the reach of our gaze, which only goes so far. A close physical inspection of the zips reveals that Newman placed a strip of masking tape on the canvas and painted up to it, which means that the zip physically occupies a deeper stratum of the canvas than do the areas of red. However, optically the zip falls in-between a cut and an overlay, thereby both concealing and revealing what lies "behind" the image. This sets up a kind of oscillation between surface and depth that has ramifications for the experience of looking at Newman's images. Such an oscillation creates the sensation of movement and temporalization; it introduces a feeling for time and gives a quasi-narrative structure to the process of looking that is modeled on representational art's handling of background, foreground, and middle distance.

This feeling is colored by the "content" of the image, a fact attested to by the different viewing experiences occasioned by other Newman works. Thus one might think of color as creating a kind of pressure in relation to the time of looking: this is why my feeling for time, my sensitivity to the temporality of the activity of looking, feels different in the face of different paintings. In *Cathedra* (Figure 7), for example, the canvas that is often taken to be a companion piece to *Vir Heroicus Sublimis*, an interesting contrast emerges. The dimensions of the canvas are pretty much identical to those of *Vir Heroicus Sublimis* (which is larger by a quarter of an inch in height and width), as is its organization of zones and their geometric relations: the central panel of *Vir Heroicus Sublimis* has been duplicated in the two squares that are hinged by the white zip. What has very obviously changed, however, is *color*, and color exerts a pressure upon my sen-

sitivity to the time of looking. I do not mean to raise a set of meta-physical speculations on the associative significance of specific col-ors—blue relates to melancholy, red to anger, and so forth—because although such associational prompts *may* intervene in the process of looking, I do not find my response to these paintings in anything like a semantic register. Their content does not lead me to speculations of the kind that would sanction metaphorical readings. This is because the content of these canvases is not, properly speaking, color but the time of looking occasioned by color, the time of color. What is evident in the comparison between the two canvases is that each has a distinct time scale, two different ways of *marking time. Vir Heroicus Sublimis* leaves its trace in the sands of time—it feels *timely*—whereas *Cathedra* arrests the onward flow of temporality; its central band of white, the hinge or fulcrum between the two squares of blue, cleaves time into the ticktock of the clock. With *Vir Heroicus Sublimis* I see time, whereas with *Cathedra* I hear its punctuation.

What I have called the pressure of time in the activity of looking cannot really be understood in relation to a conscious strategy on the part of the artist—conscious in the sense of there being an intention to convey or represent that pressure. Rather, the artist appears to rec-ognize what the image *does.* Newman seemed to have been aware of this, as the following comment suggests: "My paintings are con-cerned neither with the manipulation of space nor with the image, but with the sensation of time."[6] But this sense of time has another, historical dimension of which Newman was also deeply aware. His entire project announced itself, of course, as precisely *timely.* In a series of essays, reviews, letters, and catalogue introductions New-man prepared the world as much as himself for the painting he was to uncover on his fifty-third birthday. Among these writings is an essay entitled "The Sublime Is Now," first published in *The Tiger's*

Eye on December 15, 1948, a month or so before Newman made the work that became *Onement I*, which raises the issue of the timeliness of his painting in interesting ways.

The essay begins with a highly truncated discussion of the sublime from Longinus, through Burke and into Kant and Hegel. This takes up the first two paragraphs; in the following paragraph Newman turns to pictorial tradition, explaining the Renaissance in terms of a struggle between the sublime and the beautiful. According to Newman, modern art found it so difficult to follow the standard set by Michelangelo that it developed the desire to destroy beauty. However, without a correlative sense of the sublime, modern art merely became entangled in and obsessed with the "question" of beauty, a question that in its most basic form asks, "What is art?" What makes one thing an artwork—beautiful—and another not? Because of this obsession, so Newman's argument goes, considerations of beauty always superseded the attempt to realize a new way of experiencing the sublime. Although Michelangelo "set the standard for sublimity," it fell to those who came after him to meet his standard. As Newman comments, however,

> . . . modern art, caught without a sublime content, was incapable of creating a new sublime image, and unable to move away from the Renaissance imagery of figures and objects except by distortion or by denying it completely for an empty world of geometric formalisms—a *pure* rhetoric of abstract mathematical relationships became enmeshed in a struggle over the nature of beauty, whether beauty was in nature or could be found without nature.[7]

This struggle, according to Newman, led the American artist—or at least some American artists—toward the heroic stance he associates with his comembers of the New York School. Indeed, this stance

is licensed by the fact that America has no history, so to speak; it is "free from the weight of European culture." Thus it became possible for American artists to contemplate creating a sublime art that lacked sublime content, the grand subject matter—be it narrative, historical, or devotional—that had provided the material for the art of the past. This leads Newman to pose the following: "The question that now arises is how, if we are living in a time without a legend or mythos that can be called sublime, if we refuse to admit any exaltation in pure relations, if we refuse to live in the abstract, how can we be creating a sublime art?"[8] The answer comes in the form of a desire or will to leave the weight of history behind, to be in the now, feel the present as full presence. Whereas some might feel a little uneasy with such an overtly metaphysical or mystical vocabulary, Newman himself actively sought out such associations. His designatory practice with respect to his works—here, *Onement*—makes this very clear indeed. This sense of being *timely*, of being in the moment, of being now, is characterized as a form of forgetting as well as a kind of liberation. Newman writes:

> We do not need the obsolete props of an outmoded and antiquated legend. We are creating images whose reality is self-evident and which are devoid of the props and crutches that evoke associations with outmoded images, both sublime and beautiful. We are freeing ourselves of the impediments of memory, association, nostalgia, legend, myth, or what have you, that have been the devices of Western European painting.[9]

Freedom from the past allows the contemporary artist to make art out of his or her own experience, allows the present into the practice of image-making, submits sublimity to the uncharted waters of the present. Thus according to Newman, the sublime no longer resides

in the old modes of presentation nor in the outdated forms of repre-
sentation, and still less in the *content* of those representations. As the
title of the essay states: the time of the sublime is the present. And if
the artist accedes to this moment, allows the "now" into the moment
of making art, the images Newman had in mind—those painted by
Rothko, Pollock, Gottlieb, or Still, for example—become no more
(or less) disturbing than any of the great masterpieces of the Western
tradition. Thus, Newman concludes the essay with the following:
"Instead of making *cathedrals* out of Christ, man, or 'life,' we are
making [them] out of ourselves, out of our own feelings. The image
we produce is the self-evident one of revelation, real and concrete,
that can be understood by anyone who will look at it without the nos-
talgic glasses of history."[10]

This proclamation that the sublime is now impels the work toward
an explicit interrogation of time, of its timeliness, while simultane-
ously underscoring the co-instantaneity of the sublime itself. The
sublime is defined as "now." Such timeliness, being right for the
moment, right in the moment, is also, of course, a form of untimeli-
ness or timelessness. Being in the "now" is a form of resistance to the
onward march of time; it is a hedge against the future as well as a raid
upon the inevitable decay of the present into the past. Being timely
is both being in time and outside of it. If this is how Newman charac-
terized his—and his fellow artists'—work, similar protocols bear
down upon the viewer who wishes to "get" the image. Something
like an impulsion pervades the viewing experience of Newman's
works, a propulsion toward sensing up close one's being in the time-
world of the artwork, in the moment of the sublime.

This sensation of presence—felt by both the viewer and the work
itself—came to preoccupy Newman's greatest paintings and sculp-
tures. He returned again and again to what he called "the idea of

making the viewer present."[11] It seems to me that one has to learn to accept this pressure of presence, which is to say that it does not, at least initially, feel "natural" or even warranted. This is what I meant in my opening remarks about preparing for painting by recognizing that one must accept the need to reconcile two potentially competing statements of presence. Perhaps this is why many viewers faced with Newman's canvases feel a certain discomfort or unease that has been prompted by the recognition of the demands the works make upon them. An initial sense of discomfort is not uncommon when in the presence of great works of art, and this is partly caused by the very insistent will to presence announced by such works. One way, perhaps the only way, of learning to accept "the pressure of presence" is repeatedly to encounter the sense of discomfort associated with great works. When that happens—when discomfort is transfigured into something less irksome—what I am calling this "will to presence" leads me both away from myself and, at the same time, toward a greater sense of fullness, self-presence. It seems unlikely that I will ever be at ease with such works, so to that extent the discomfort always remains. But it is precisely this residue that agitates my curiosity, prompting the onset of the state of wonder. In the case of *Vir Heroicus Sublimis*, the best term I can find for this is *serenity*.

IN THE COURSE of a conversation with the art critic David Sylvester in 1965, Newman remarked:

> . . . one of the nicest things that anybody ever said about my work is when you yourself said that standing in front of my paintings you had a sense of your own scale. This is what I think you meant, and this is what I have tried to do: that the

onlooker in front of my painting knows that he's there. To me, the sense of place not only has a mystery but has that sense of metaphysical fact.[12]

This sense of "knowing that one is there" is not something that is "captured" by the image—it could not be called its content—rather, it emerges from an encounter between the viewer and the work. I put it this way because I want to insist that my experience of this artwork is not entirely contained within the visual; my sense of this work is not wholly a matter of the activity of looking, at least insofar as that activity is commonly understood. I believe Newman was aiming for an interleaving of affective and cognitive responses that had resonance—were refracted—in a more overtly philosophical domain, as if the ocular were capable of being transformed into the ontological, as if one could see with the eye of being. In this way the somatic fact of presence, being here, at this moment in the look, comes to be overlaid on a metaphysical sensation of being. The experience of Newman's art makes me feel—both affectively and cognitively—what it is like to be, or, perhaps more accurately, helps me feel being, as if it were something I might rub between my fingers, gauge its thickness, sense its surface. This is what I mean by the observation that looking is only a part of my encounter with *Vir Heroicus Sublimis.* The experience is far from exclusively optical in the normal sense. Newman put it this way: ". . . I hope that both the sculpture and the painting give the onlooker a sense of place, a sense of being there."[13] But what is it to "know that one is there?" What kind of knowing might that be? As far as Newman is concerned, knowing does not seem exclusively to involve the evidence of sight, since any visual activity on the part of the viewer would have the same effect. Indeed, in addition to the evidence of the ocular senses,

one also needs to be able to recognize the difference between sensing, feeling—noticing that the sensorium has been stimulated—and knowing. In other words, one has to be able to recognize what it might *feel* like to be knowing something, to feel the interleaving of the affective with the cognitive. Looking, in this register, adjoins the sensation of pinching oneself metaphysically. The sense of "being there" is derived from the excitation of nonphysical as well as physical senses.

I would like to return to *Vir Heroicus Sublimis* in the light of the foregoing remarks. Looking at this canvas does *feel* different; it is not only that I become highly conscious of the activity of looking—which in and of itself is far from unique to *this* image—nor that the space (both the real physical space, the public environment of MoMA, and the pictorial space created by the canvas itself) in which the activity takes place seems highly charged. Both of these things contribute to the feeling I am trying to get in focus, which is more like an act of witnessing than an act of seeing. In fact I need to witness that I am looking before I can begin to see this image; in this sense looking is not like a visual activity at all—it is more like a recognition of presence, or a feeling of or for presence. It is almost as if something has been removed from the domain of the visual, moved from its usual place to some other, unfamiliar location. And that thing is my own identification of self-presence. I witness myself as there not through ocular corroboration—I am not standing in front of a mirror—but through the decomposition of the sense of sight into another sense (what Enlightenment thinkers called an internal sense or taste). This produces a compelling sensation of tactility in vision, as if sight included the sense of touch. In an interview with Dorothy Gees Seckler published in 1962, Newman put it like this: "Anyone standing in front of my paintings must feel the vertical

domelike vaults encompass him to awaken an awareness of his being alive in the sensation of complete space. This is the opposite of creating an environment. The environment is separate from the painting."[14]

In this section of the interview Newman was responding to the notion that his paintings were in some manner hostile to the environment in which they were displayed, and therefore created their own "environment" in order to be seen properly. Newman objected to this by pointing out that his images create a sense of space. In the terms I have been developing, that sense of space is a correlative of the distance we take to the image. Newman's canvases—large or small in size—raise the question of distance in particularly interesting ways because size is not a good guide to the viewing position required by the image. A brief anecdote illustrates this point well. I last saw Vir Heroicus Sublimis during the large Jackson Pollock retrospective at MoMA in 1999. The rooms usually occupied by the permanent collection had been taken over for this extremely extensive show, thereby necessitating the removal of some of the permanent collection to the basement space usually reserved for revolving exhibitions. Among those artifacts was Newman's canvas, which was hung on the wall at the far end of the very long room at the bottom of the stairs. The long approach to the canvas was, therefore, rather like the sensation of a movie camera zooming in on its object. Seen from this considerable distance, the canvas looked inert—an insertion of color into the space of the museum and no more—and in a strange way its size dampened down the sense of its compelling us to look or be with it. Newman himself remarked upon this aspect of his large paintings: "There is a tendency to look at large pictures from a distance. The large pictures in this exhibition are intended to be seen from a short distance."[15]

Newman's pictures overtly pose the question of distance; they ask the viewer to scale him- or herself as an act of witnessing the work. This requires the viewer to accept what I have called the necessity of reconciling two competing statements of presence: that made by the image and that announced by the viewer. In the reconciliation of these two positions the distance between viewer and canvas is all but erased, for the optimum point of sight is identical to the space occupied by the image, suggesting that the canvas itself is a part of the picture-seeing mechanism. Seeing, here, is a function of the negotiation and renegotiation of agency in the optical domain. What I see is seen under the auspices of what the image presents to sight, what it lets me see. Indeed, to put it one way, the picture itself "sees" me as much as I see it, and this is certainly a function of distance. Thus, the optical has been muffled to such an extent that the viewer becomes, as it were, color-blind even as the time of color pervades the experience.

This feeling for time is intensified by the sublimated narrative structure of the form of *Vir Heroicus Sublimis*, which I think of as an echo or after-image of the traditional devotional hinged polyptych. This partly accounts for why I find Newman's horizontal zips in paintings such as *Argos* (1949; Figure 8) or *Dionysius* (1949; Figure 9) less compelling. They fragment the viewing experience along the wrong axis, as if horizontality remains too mired in the worldliness of things, anchors the experience too firmly in the optical or the physical senses. It is almost as if the horizontal zip is there to be read or interpreted like a line of type. I certainly find these images less successful, less satisfying; they seem to soar less than those containing vertical zips. Strangely the opposite is true of Rothko, whose verticals seem inert, lacking resonance, whereas his horizontals are vibrant, irresistible. So if *Vir Heroicus Sublimis* has, at some deep or

unconscious level, sublimated the formal organization of the polyp-tych, what significance can be attached to the fact that what would be the outer panels are rendered immobile, that the physical hinge has become a mark or line on the surface of the canvas? What is the image forcefully laying bare, permanently exposing to view?

I take it that the nakedness of presentation—this is red—is ampli-fied by the fact that the outer panels, as it were, cannot be closed over the central zone of the image. As a result, there is a distinct impera-tive encoded in the viewing experience to close one's eyes, almost as if the immovability of the polyptych's outer wings compels a substi-tute form of movement, the closing of sight. When this happens it occurs to me that closing one's eyes the better to see is no bad thing. In any case, the blinking on and off of vision intensifies the sense of proximity I have to the picture plane so that I come to feel my own space wrapped up in the single presentation of color that the image seems to sound out loud. First I look, then I see with the clarity of an after-image while my eyes are closed. First I present myself to the image and then I feel myself to be close up to it, breathing almost in its body. And in this oscillation between here and there I become increasingly wide-eyed, the better to see. Once again I am prompted to ask: What does this artwork know? I phrase this question in full light of the fact that it is virtually unintelligible—it might be slightly better to recast the question as, "What is its way of knowing?"—but this does not detract from the very powerful sense I have of getting closer to the work, closer yet still not close enough. This leaves me with the virtual impression of a depth to the work, of something con-tained within it that I have yet to fathom, a space I may, perhaps, never inhabit.

This is a devotional painting. It invokes in me the same kind of excited admiration I register in the presence of Piero della Fran-cesca's *Madonna del Parto*. It absorbs my will-to-presence. A way of

getting closer to that sensation is to compare my responses to this canvas with my responses to different ones, both by Newman and by other artists. How, for example, does my response differ from that elicited by *Cathedra*? Or from Rothko's similarly abstract canvases? The strongest affect I have in front of *Vir Heroicus Sublimis* is composure; the image seems to compose me, to generate a sense of well-being, of being at one with myself. This sensation of calm, tranquility, allows thought to breathe. I know things differently when in this state; indeed, I recognize that I know things that in other states are not accessible to me as knowledge. Looking at this painting requires me to learn to still my gaze—precisely the opposite mode of looking required by, say, the "drip" paintings made by Newman's fellow New York School artist Jackson Pollock. This calm, composed, tranquil space is the material of my affective response, and it feels quite distinct from that generated by the so-called companion canvas *Cathedra*. In the presence of the latter's statement of blue I find something more like self-command or grace than tranquility. *Cathedra*'s geometric organization has weight, seriousness of purpose, whereas an equally formally organized image such as *Vir Heroicus Sublimis* creates a set of harmonics that, though leading to a sense of composure, nevertheless lack the exactitude of *Cathedra*'s ensemble.

To take a different example, in *Achilles* of 1952, the ragged edge of the central red panel leads the eye away from anything like the sensation of serenity. The image lacks the calm or repose of *Vir Heroicus Sublimis*: it agitates my sensate experience, causes a febrile retina, leaves me wanting, discomposed, over-excited, and unable to locate myself. I certainly feel the difference of color; *Who's Afraid of Red, Yellow and Blue IV* (1969–1970; Figure 10), with its opposing squares of red and yellow, feels more open, joyful, and confident than *Achilles*. This canvas, among the last Newman painted before his death on July 4, 1970, almost swaggers with painterly conviction. As

its title suggests, nothing seems to be beyond its powers of presenta-
tion. Yet I do not feel oppressed by its mastery; I am taken up in its
proud confidence, empowered yet also spellbound by its majestic
assurance. In the face of this canvas I sense both affectively and cog-
nitively what it is like to be here in *this* presentation.

If I compare Newman's intellectual touch with the far more physi-
cal canvases of Rothko—say, a canvas like *Black over Reds* (1957; Fig-
ure 11), which shares similar or nearly identical chromatic registers
with *Vir Heroicus Sublimis*—I can note further differences. In the
case of the Rothko image the variation in depth perspective created
by the layering of chromatic values gives a plangency to the viewing
experience. Rothko's painting articulates distance—the address of
the viewer as well as the depth of the image—very differently from
Newman's. If I move close up, what I first take to be a sense of depth
created by the black panel becomes a surface; if I move far away, the
stepping of the shades of red becomes less evident. But I have to
move—up close and far away—in order to pick up the jangled fre-
quencies of chromaticism. Newman, as he himself remarked to
Clement Greenberg, did not play with chromatic registers. His color
is pure, as if stamped out of a larger expanse, a "die" rather than a
stain. And this attitude to color, his letting it shine or breathe, creates
a feeling in the viewer very different from that which results from
Rothko's work. And this difference is in part a function of distance.
With Newman, too close is not really a possibility; looking has to
transform into being with the image, sharing its presentation. Thus,
whereas I have spoken of serenity as the appropriate word with
regard to my affective response to *Vir Heroicus Sublimis*, I need a dif-
ferent word, sonority, to convey my response to *Black over Reds*
(1957). Looking at this Rothko canvas creates a sense of resonance, as
if both the painting and my *aesthetic* experience of it resonate with
the world.

Throughout this chapter I have attempted to convey in slightly different ways what a response to the question "What does this artwork know?" might be. My resting point in the term *serenity* is meant to describe the *content* of the art component of *Vir Heroicus Sublimis*. Since that content is only accessible in the form of my affective response to Newman's canvas, it could also be taken to be the content of that response. The two are mutually dependent; each is made visible only by the other. This, however, should not be understood as the discovery (or identification) of a feeling of (or for) serenity. Such a feeling is an adjunct to the *aesthetic* response, and though it may help in directing attention to the right place, it is, strictly speaking, a side-effect or residue of the response. This is to say that my feeling "serene" may or may not accompany my *aesthetic* response to this canvas. It is entirely possible, for example, for someone else to feel something markedly different when confronted by this painting but still be able to perceive the serenity of the work.

Insofar as I am able to answer the question I have posed—What is *Vir Heroicus Sublimis*'s way of knowing?—I have turned to the content of my affective response. But I want to stress that "feeling" is not the only material I encounter there. Indeed, my affective or *aesthetic* experience is held in a more rarefied atmosphere than feeling, between emotive sensation and cognition. I ask myself the question of knowing because by doing so I turn attention away from the purely sensate. And that question of knowing appears to me as a quality of the work itself. What this canvas seems to hold to itself yet also offer to me is serenity. And when I pick up on this, gain access to it, by some mysterious way tune into its frequencies, I am as deeply moved as I ever have been.

3

Clarity: Glenn Gould's *Goldberg* (1981)

HOW SHOULD ONE ADDRESS the art that is music? Here I am inquiring not only about the physical disposition of the activity of listening—the attentive ear and tensile body that characterize the somatic presentation to music—but also about the necessary mental preparation required for the acceptance of music. My question, then, could also be phrased as, How can one prepare for music?

Thinking about the matter in this way highlights the differences between music and the other arts; unlike visual art, which has the capacity to strike us unawares—as if being prepared for looking is only one form of address to the visual and not a necessary precondition—with music we must first hear sound *as* music. We can, of course, be struck by a sound, caught off-guard by it, just as music itself may lay in wait for us, surprise us, but in this second case we must already be listening with the music. Visual art has a greater

propensity for astonishment because its modes of temporalization allow for perceptual instantaneity, whereas music inhabits a time-world of process, continuum, sequence: its modes of temporalization require us to make adjustments with its unfolding, either in step or out of step, and lead us toward listening in time. As a result, music has an inescapably complex relationship to temporality—something that will become increasingly important in my attempts to unfurl what it means to *play in time*, and what it might be to listen at the end of time, where time seems to run out. This complex relationship to temporality makes it impossible for us to talk of suddenly coming upon music, as we might do in relation to a work of visual art, and so I begin by asking how one might prepare for music.

In attempting to define the art that is music, we come across a fairly clear distinction between sound and music, or noise and orga-nized sound. This seems to mark music out from the other arts, where such distinctions are less clear-cut—in visual art, for example, the boundary is less discernible—but with music, sound that has no intentional structure, that is, sound without intended form, cannot be heard as music. Music keeps at bay the sound of the world. This does not mean that such sound cannot be framed by music, or even a part of certain kinds of music (noise may be enveloped by music or even, as in Karlheinz Stockhausen's *Helicopter Quartet*, be used as a counterpoint to music), but it does help in directing us toward an analysis of one of the basic attitudes we must take to the sound we hear as music: the listening ear must recognize something like struc-ture or pattern, the impress of an intention to organize sound thus. We do not, necessarily, listen *to* that form or structure; indeed, we are most often inattentive to it, though we do listen with it. In this sense listening with music is to be distinguished from listening to it. It would be unusual, for example, if I were to say that I am listening

with the sound of the world—I might say this if I am attempting to become distracted from the sound of my being, as if I were constantly aware of the sound of my own breathing or the beating of my heart—but not so strange or awkward if I were to say that I was listening *to* the sound of the world. This tells us that a certain form of attention accompanies our making ready for music; we encourage the development of an attentive mode that will enable us to listen with music, and it is this mode that I take to be a preparation for listening in time.

Listening *to* something is based on an intentional activity in which the object attended to is bound up with the intentional act, whereas listening *with* something proceeds in a more inattentive manner, as if one might listen without direction, listen unintentionally, thereby arresting the natural directiveness of the listening ear. Moreover, listening with music may be only intermittent, as attention itself flickers on and off, directs itself here and there, moving around the soundscape, now directed toward the bass, now toward the violin, now the left hand, now the right. Nevertheless, this blinking of attention only helps distinguish what we listen *to* from what we listen *with*.

This points to another feature of music that helps us distinguish it from mere sound: the temporal envelope that contains both the sound and the attentive state in which that sound is heard. That envelope has a structure, an identifiable form or shape, because music's being is in time. The materiality of music, then, is the combination of two things: sound and time. Music, as an art form in common with all art forms, at some level interrogates its own materiality. Music is an interrogation of the sound of time and the time of sound: this is the argument that makes music art. Such an interrogation involves inquiring into the specific qualities of time that

determine and segment music's being, into its own senses of temporalization. It is useful to note here that music does not tell the time, although we may tell time by it. Our becoming aware of this duality of temporalization, that is, the tension between the "real time" in which music is played out and the time of music, enables us to glimpse what I have called the argument of art. And it is this dual perspective on temporality resulting from an encounter with music that leads us to intuit something about the world of the artwork.

In order to understand temporality as it relates to music, it is useful to explore the activity of listening as a parallel to the discussion of looking in the previous chapter. The kind of listening I characterized a moment ago, the listener's activity, should be distinguished from a player's or musician's listening practice, which is more commonly directed to the sound she or he makes. This is because the kind of concentration required for making music is not the same as that needed to listen to it as a non-player. Furthermore, the activity of listening to music as a non-performer may result in a very different form of concentration than that adopted by a performer, transforming the listening activity into what I earlier identified as a way of listening *with* music. Performers and listeners alike may inhabit both forms of concentration, but that of the latter is more an inattentive than an attentive mode. This mode is unusual in performers, though as will become apparent, it was Gould's preferred means for the realization of music.

In listening with music we very often describe the affective experience in terms of "feeling"—this is so to a greater extent with music that with other art forms, although it is, of course, encountered in descriptions of visual art, literature, and so forth. Preparing for music, then, might be understood as a preparation for or willingness

to entertain a particular kind of feeling. Very often the nature of this sensation remains mysterious, slightly out of reach, since the fact that sound itself does not have a semantic register makes it impossible to describe the "feeling." Although some kinds of music—say, program music—are sometimes discussed in something like semantic terms, as if their pitch or melody were somewhere within the realm of language, this remains an anomalous case. Yet the sensation of being emotionally involved in sound is so common a part of listening with music that it seems strange that we have so impoverished a vocabulary for talking about, exploring, and analyzing affective responses to it. As I remarked in the Introduction, it is frequently said that any attempt to put such sensations into words would run the risk of destroying the response. This sentiment, however, is also commonly accompanied by a need or desire to communicate that feeling, to share it with others. This more or less intense compulsion most often finds its outlet in a physical expression, as if our somatic presence to music sets up a kind of sounding board that resonates along with the sound we hear. The feeling we experience, then, often has a physical component; indeed our physicalization of listening, the somatic presentation of listening in time, may on occasion be taken to be evidence for our feeling, evidence that we, the listeners, are in the same time and space as the music itself, part of its habitus, its sound world.

What exercises of the inward ear do we need to practice in order to be ready for the moment of transformation when the sound we hear is understood to be music? I do not take this, at least primarily, to be a question concerning musical education, or the competence one may acquire through exposure to a wide range of those sounds we call music. Such education undoubtedly has its part to play in the training of the ear—if one has never heard contemporary classical music before encountering, say, Cage's works, it is unlikely that

the listener will be immediately at home in their sound world—
but this training is subsequent to the moment I referred to above; it
augments the listener's initial address to what is heard, which most
effectively sorts out music from the sound. This address is most pro-
ductively investigated in terms of the forms of attention we bring to
the listening activity, and so I now turn to the phenomenology of
attention.

ATTENTION HAS A DIRECTION, a trajectory; attention
intends. We know this because in attention one attends *to* some-
thing. Given this fact, it follows that in attending *to* something we
simultaneously inattend around everything else. Attending *to* some-
thing is a way of making present to hand, holding something within
the confines of our perceptual reach—say, within earshot—which
necessarily renders everything else in the perceptual field below
the level of attentive audibility, beyond earshot. Attention here is
something like holding the object at the correct distance, as if at
the correct focal length or within audible reach, and what is
being attended to is, at least in part, the mechanics of maintaining
the object at such a distance. When unable to hear distinctly, for
example, we are unlikely to say, "move closer" rather than "speak
louder," but either will do. This underscores the point that distance
is a necessary component of attention; it has, say, a focal length,
hence the sense that at closer ranges or more distant reaches things
are relegated to the field of the inattentive. My opening question,
then, might be recast as, "What is the correct distance to take to
music?" Attention always comes attached to the inattentive, since in
bringing one thing into the right distance everything else is removed
to different distances. But are these things any less available to us,
less known on account of that incorrect distance to the attentive ear

and eye? The question here seems to be, What is known to us in inattention?

The more one attempts to answer this question, the stranger the notion becomes that one knows what one *attends* to. Can I attend to listening, to the process itself? It is almost as if I must attend to something else in order to know that I am in fact hearing—I know this by turning my attention not to the process but to sounds. I know I am hearing by the sound of the world, the noise outside my body, but I do not know this by attending to the activity itself. The former feels more like being held captive in a sound or set of sounds, more like being entranced by the world than taking a distance to or from it. I am inattentive to the activity of listening, indeed, I must be so in order to note that I am, in fact, hearing. This suggests that a phenomenology of "attention" as such is not possible; any phenomenological account should more correctly be focused on the composite term "attention-inattention," since the one always accompanies the other.

So how might one begin to investigate inattention so that its phenomenology may become clearer? As a way of starting, it is useful to reinforce what was noted a moment ago in relation to the composite character of attention. Inattention is not the opposite of attention; indeed, attention *includes* inattention. Attention *happens*, which is to say that it is an active engagement with the world; it presents the intending agent to the world. Consequently, in attending *to* something I am in effect making present presence, and in so doing I experience myself as being present to the object of attention. This, in a certain Heideggerian vocabulary, might be called a recognition of my being ready at hand. The opposite of attention is distraction, the inability to focus on a single thing and the subsequent scattering of attention across a very wide field: the rapid focus and refocusing on a

succession of perceptual objects and the consequent inability to remain attentively engrossed by any one of them. Attention is purposive, distraction is without purpose. I may, however, intend to be distracted, say, in order to resist attention, and in such cases my awareness of both attending to something—here being distracted—and inattending to everything else is heightened.

In an obvious sense a phenomenology of inattention would be impossible, since in bracketing out what we habitually attend to in order to attend to the inattentive we render the object of our attention attentive. While at first glance this looks as if it delivers a truth about the phenomenology of inattention, on second thought it raises the question as to whether in attending to something we necessarily render the thing itself attentive, as if attending to something is equivalent to a call to attention, thereby implying that the thing itself might be called to attention, asked to sit up straight. Now one might say that in a strange way the thing itself attends, as if it has an active response to having attention directed at it.

We can call our attention to nothing and, the moment we do so, we are flooded with thought, with the *unattended to*. But this *unattended to* should not be equated with inattention, which is within attention itself, as its "in" playfully suggests. This means that we may inattend to the *unattended to*, thereby attending to the unintended. In attending to the *unintended* through inattention, we make what we have previously kept out of attention sit up and attend to us, to our attentive gaze; we ask it to pay attention. Consequently, an inquiry into the *unattended to* is precisely not an investigation into inattention; in making the *unattended to* into an object of attention we call to attention that which we have overlooked. An inquiry into inattention must be a call to attention of attention itself. In other words, a starting point for a phenomenology of inattention

must be attention; it must begin by asking what the "in" in inattention attends to.

ARE THERE SPECIFIC OBJECTS or forms that regularly fall within the domain of the inattentive? The everyday, the ordinary, the overlooked, the underheard, the unremembered, the unremarked, the unremarkable? Is it because these things are too *near*, too close up for attention to see them that they "naturally" fall within the domain of the inattentive? This is to ask once again about proximity, about taking the right distance or attitude to a sound. These things, the ordinary, the everyday, and so forth, often have a strange power, call it the uncanniness of their proximity, to slip *behind* attention, almost as if they constitute the screen upon which attention shines its light, thereby making the screen itself both unavoidably visible and, at the same time, invisible, the surface past which we must look in order to see what is projected on it. The ordinary is extraordinary in its ability to go unremarked, and this is all the more remarkable for the fact that we constantly need reminding that our habitat is not, or not commonly at least, within the domain of the everyday. Perhaps this tells us something about our longing for the everyday or the unremarkable. It is not so much that we are unattending to this realm, as if we do not care to question it, notice it, but that in order to survive, find a habitus, we need to construct a mode or mood of inattention, create a domain too close for the reach of attention, a site so inward, revelatory, so uncomfortably intentional that if we were to pry into the accessibility of our attentive gaze we would blush with the pain of self-recognition or self-exposure.

When we talk of our attention being held, we most commonly figure this as a cessation of motion, a coming into stillness, as if atten-

tion is habitually restive, on the move. When our attention is held the stillness of inattention comes into view, almost as if the pressure on attention requires the relief of inattention. What is so single-mindedly looked at, brought into sharp focus, listened to, allows the release of focus in the inattentive. The sound of music floods over us. Attention is never still, always roving, never steady, which is why when we look attentive we present ourselves as ready for attention, ready to attend. In this sense being at attention is a preparation for attending to something, for being in-attention. But how do we prepare ourselves for inattention? If the quieting of the mind, making consciousness still, is a preparation for attention, is the opposite, letting in the noise of the world and of others, a preparation for inattention? When I look vacant I present myself to attention, whereas when I seem preoccupied I present myself to inattention; being in the state of "all ears" or "all eyes" is a making ready for the inattentive. This says something about how one might prepare for the activity of listening to music (and looking at paintings) and suggests that the somatic markers of rapt attention that one so often encounters in the concert hall or gallery are indicators of the inattentive.

I have taken this space to outline how a phenomenology of attention might proceed in order to ask my initial question in a more focused way. Now my opening question can be answered along these lines: in preparing for music we must learn to prepare ourselves for inattention. I do not want to suggest that these two things are identical, but the one, music, will have a hard time surfacing without the other, the state of inattention. There is a great difference between knowing this as a proposition, a theoretical elaboration, and knowing it as a form of experience, as a truth of the activity of hearing sound as music. In order to explore these observations, I turn to an example of my own affective response to a work of art.

MUCH HAS BEEN WRITTEN about the Canadian pianist and broadcaster Glenn Gould—a good deal while he was alive and considerably more since his death in 1982. It seems unnecessary to repeat the substance of what can be found relatively easily in three books—Geoffrey Payzant's *Glenn Gould, Music and Mind*, Otto Friedrich's *Glenn Gould: A Life in Variations*, and more recently Peter F. Ostwald's *Glenn Gould: The Ecstasy and Tragedy of Genius*—and one essay by Edward Said, "Performance as an Extreme Occasion" in his *Musical Elaborations*, but I will nevertheless extract a few salient points from this literature by way of introduction. Gould was an extraordinary man, some would claim eccentric, others that such eccentricity is merely the outward sign of real genius. Opinion regarding Gould's considerable discography is also divided: for some the quirky and at times strenuously original approaches he took to the music that he recorded overwhelm the listener, directing attention away from what Bach or Mozart wrote, while for others it is precisely these features of Gould's approach that allow them to hear anew, to listen more intently to Bach's or Mozart's scores.

Arguments of a musicological kind may be entered into here— regarding, say, whether or not works written by Bach should be played on a contemporary piano, or any piano at all, or about the relationship between the piano as a solo instrument and the orchestra in the concerto repertoire from Mozart to Beethoven. Gould's very definite opinions about these and countless other musical issues often diverged from the prevailing professional consensus. Perhaps his most "eccentric" set of opinions concerned the "live" playing of music: Gould, as is widely known, retired from the concert platform at what must be regarded as an unusual point in his career—he

had arrived at the pinnacle of concert performance, in demand the world over, feted by audiences from Moscow to San Francisco—and dedicated the final eighteen years of his life to recording at the keyboard and recording radio and TV programs of a quite varied kind, including, for example, documentaries, dramas, interviews, and performances.

Gould disliked what he called the gladiatorial aspect of the contemporary concert hall and hated the pressure put on soloists to display virtuosity (for the same reason he had a very low opinion of most of the romantic concerto repertoire). It was this bravado of display for its own sake, he thought, that led to a certain inauthenticity in performance that was damaging to both the musician and the music. We can get a sense of the peculiarities of modern performance culture if we imagine what it would be like to turn up at a public concert venue and hear a recording. Although the music in the sense of the notes written down by the composer clearly plays a part in our experience of the concert hall, it is by no means the only, or even the most compelling, aspect of the experience. These matters are, of course, quite complexly embedded in the Western history of concert performance—in the social, ritual, and political accents of performance culture, all of which Gould preferred to minimize if not sidestep altogether.

He believed that, compared with live performance, the modern recording studio gave the musician far greater control over the final product, the sound one hears, and that "live" performance with all its imperfections would quickly fade away. He was clearly wrong on this last matter, but in relation to the first he ruthlessly exploited the technology at his disposal in order to produce "composite" recordings made up of a number of takes that at least as far as he was concerned best conveyed the music he sought to realize. Such "composite" recordings are commonplace today, but in the 1960s

when Gould began to exploit the developing technology of the recording studio, the notion that one might artificially construct a finished recording through multiple takes, splices, and even over-dubs was only beginning to be accepted. Nevertheless, it is not the fact that Gould's recordings are made up of a number of discrete takes that irritates his adversaries, but rather his tireless and enthusi-astic exploitation of recording technology and consequent disparage-ment of the concert platform. Gould claimed that the recording was *better* than the live performance, that it was *more* musical, not less.

For Gould the recording studio and its developing technology rep-resented the purest and most efficacious environment for the pro-duction of music, the making of art. There could be no "better" or more enthralling live one-off concert that encapsulated the "spirit" of the music or realized the composer's score more adequately. For him authenticity was not compromised by the ability to correct mis-takes. Consequently, in listening to the recordings Gould made we are as close to his sense of the transmutation of a score into the art that is music as we can ever get. This is one reason I have chosen a recording by Gould, his second account of the *Goldberg,* as my musical example: as far as he was concerned, it is more authentic in terms of its status as art than any live performance of Bach's score could ever be.

Another, more rudimentary reason is that in order to speak about the art that is music one must always, necessarily, address a specific *realization* of a particular piece unless one is presenting musical analysis. Playing the music ourselves is obviously one way to gain access to the sound; recordings, of live concert performances as well as studio work, provide us with another. This sound is the material on which any elaboration of an affective response to music must be based. In all cases the specific environment in which the sound is realized—concert hall, practice room, living room at home—neces-

sarily affects how we hear and what we listen to. For this reason we should take care to note that recordings of live performances do not capture the performance as it was: such recordings belong to a genre of listening experience that is different from the live event, and they are different again from studio recordings. Furthermore, the social environment of the concert hall must be clearly distinguished from the private space of the home. Listening—on a pair of headphones, say—not only sounds different from listening on speakers but also has a distinct place within the practice of everyday private life. The illusion of a deep interior, closed-off private world of the work is much more marked when the sound source is not only close up to one's ears but also effectively closes out all other sounds.

Gould was deeply aware of both the ritualized public aspects of the concert hall (which he loathed) and the changing practices of musical education and enjoyment brought about by developing recording and playback technology. In this respect his seriousness of purpose was exemplary—perhaps crazed—he understood the *textual* nature of the recording process and set out to fashion and control as tightly as he could the resulting text. The technology of the studio, therefore, was there to be exploited for *musical* purposes and ends: it enabled Gould and his collaborating technicians to create as accurate a text for the listening experience as was possible. In abandoning the concert platform, Gould was not opting for the easy solutions and quiet life of the studio—avoiding the stringent, harsh, and unforgiving discipline of live performance—but attempting to make his life more accountable, more answerable to the rigors of making music, creating art. For Gould, then, the recordings he made after his retirement from the concert stage were not less authentic or musical than previous recordings of his live performances; on the contrary, they represented a new breakthrough in making the art that is music.

For some critics and concertgoers Gould's retirement was a relief because it removed from the public domain a player of such pronounced idiosyncrasy that his ticks and mannerisms had become the "content" of his performances. Put bluntly, his playing style or technique—the posture, flattened hands, ridiculously low chair, humming, and self-conducting—distracted audiences from the task at hand: the realization and appreciation of the music. For others these eccentricities only served to intensify the magic and mystique of Gould's concert appearances. One might initially think, then, that the seclusion of the recording studio would have removed these barriers to listening, thereby enabling the listener to convert distraction into attention. But such a view ignores the great importance that the sense of presence has to the experience of hearing music. And in relation to this, Gould's presence at the keyboard seems to me one of the most crucial and extraordinary characteristics of his approach to making music. It is certainly one of the determining elements in how we hear his playing.

Of course it is true that any and every keyboard player must physically address the instrument. In some cases an attempt is made to minimize the effect a particular address has on the sound we hear. If this is so, the performer sets out to "touch" the music as lightly as possible, impressing him- or herself on the composer's intentions, the scored notation, with the greatest delicacy. Such attempts to erase the presence of the performer go hand in hand with the notion that the aim of performance is to achieve transparency, putting as little in the way of the direct communication of the composer's intentions to the listener as is humanly possible. Connected to this approach to performance, one often finds the correlative notion that the performer should strive to be as "faithful" to the score as he or she can. Performers who hold to this view insist that one should play the notes

and only the notes written by the composer; any embellishment, giving body to the music, is frowned upon.

This rather rigid and puritanical approach to performance is fortunately very rare (and some would say impossible). Most, if not all, professional players recognize the impossibility of erasing their presence at the keyboard and turn this into a virtue: a signature or "trademark" is established so that the sound itself bears the mark of that physical presence. It is important to note here that I am not talking about a playing style as such, nor about the various pianistic traits that might be associated with one player or another. Still less do I mean to refer to the decisions of "interpretation" that may result in one player's realizing the score in markedly different musical ways— this is especially evident in baroque keyboard music, where, among other things, the player is required to contribute his or her own interpretations of the ornamentation that is left open in the score. It is not this stamp of the performer I mean to refer to but something more elemental, even more ineradicable: the relationship between a real physical presence at the keyboard and the sound produced. The great American jazz pianist McCoy Tyner, for example, plays with such unparalleled *strength* that we hear the force of his physique in the sound—and I do not mean by this the volume he manages to create at the keyboard. The sound bears the impress of a physical presence, whether or not he is playing loud crashing chords or softly diminishing runs, and that presence is predominantly characterized by its power, weight, force, and strength.

A player of quite different presence is Alfred Brendel, whose physical impress upon the sound moves in and out of extremes of tension. This creates passages of such tautness that we often crave the release of tension—a feature of his playing that allows the music to breathe, for a playful, even comic sense to be conveyed in music of

the greatest seriousness. Once again I wish to highlight the *physical* address of the player that is impressed upon the sound we hear. I do not mean to characterize Brendel as a "tense" player in the normal sense of the word—he is in many respects one of the most intellectual pianists ever to record—but rather to signal that what we hear in the music as a pulsation between absolute tension and its subsequent release, one of the means a player may use in creating "intellectual" approaches to music, has its base in a physical disposition. The supremely intellectual interpretations of Schubert's *Impromptus,* Op. 90 D. 899, for example, which contain moments of deep serenity as well as playful wit, moving from the grandeur of the opening of the first impromptu in C minor to the delicate tracery of the opening of the fourth in A flat are realized not only through an intensity of thought, of concentration, but also through a physical training— including but not restricted to the physical exercises of the fingers— which might be termed a "tensation," a tensing and release of the body in order to communicate more subtly the sense Brendel both makes and communicates in this music. It is this physical address that, in a player of extreme skill, signals something to our inattentive ear as the affective experience of listening allows us to enter into the interior of the art that is music, of being in time with the music. The impress of the physical guides us, directs the listening ear toward being in step with the temporal unfolding of the music, enables the listener to feel at one in its environment. Such anunconscious sense of physical presence may give rise to a conscious feeling of one's own physical presence, and if this happens, the listening ear feels itself right up close to another body, perhaps even inhabits a simulacrum of the *space* of that body. And once again I find the question of distance to be crucial: How close is too close, how far away is proper? However we answer this question, in my view, the physical response that so often characterizes the listening experience is directly con-

nected to our being moved in the affective sense. This is why some have said that dance is the most appropriate response to music.

In the case of Glenn Gould this physical address was, perhaps, all too noticeable. Not only did he famously insist on using a battered old chair set at a ridiculously low height, but he also conducted himself at the keyboard when a hand came free, and he generally moved around and fidgeted, all of which many audiences initially found immensely distracting. But once removed from the concert platform, the somatic resonance that persists in the sound of his recordings has a different air: Gould appears to be both in a state of intense rapture, caught up within the sound he makes, and, at the same time, attending elsewhere, as if he were inattending to his playing. And this is not to mention the all-too-audible vocal accompaniment. But as eccentric as this undoubtedly was, few if any players have exploited the physical address to the keyboard so relentlessly and, in my view, so effectively. I know of no other performer—except perhaps one of the great originals of jazz, Thelonious Monk—whose physical imprint is so legible in the sound produced. (Again, here I am referring not to his vocalization but to his somatic presence at the keyboard.) Gould as a person was, according to almost every account, incredibly uptight. His eccentricities and obsessions—with the temperature, his hands, his general health and well-being—were never far from the surface, and even if, as is clear from numerous testimonies from friends and acquaintances, he could also be humorous, kind, and gentle, he was nevertheless physically tense (presumably this was partly responsible for his preference for friendships conducted entirely via telephone). Yet to see him on video at the keyboard is to witness someone totally at ease in music, in his being-in-music: his physical presence is *part of the sound* he creates. It is almost as if the curious height of the chair and flattened hands deliberately seek to preserve his sense of body space, to make his own

physical presence present to the sound created. And this, of couse, is Gould's own signature, his own particular form of physical address to the sound we hear.

Perhaps a sculptural metaphor will help here: Gould approaches the keyboard as if he were molding something—in a way he is, of course, molding sound—creating a physical artwork, say, impressing clay with the shape and outline of his hands. But the touch is so light, as light as breath, that such a physical analogy seems too crude. Another, and perhaps more helpful, image comes to mind: that of Jackson Pollock waving his hands, arms, body above the canvas stretched out on the floor, and those balletic shapes Pollock made in the space above the canvas that left their imprint in the form of the "drip" paintings he began producing in the late 1940s, turning the canvas into a form of silvered gelatin, a second state of the artwork that existed first in the space above it. Gould's physical impress is similarly ghostly, spectral yet all too close up: it has an almost unbearable lightness, yet we hear it loud and clear in the sound he produces, which on many occasions seems to become weightless, cut from its material base; and it is this that beats sound into the airy thinness of music. But this sound is also, curiously, almost like a residue, what is left after the impression of Gould's musical gift; rather like Pollock's canvasses, it is the trace left after Gould's presence has vanished. The listening experience starts with the sound Gould made, with the physical agitation of the airwaves that impress themselves upon our perceptive mechanism, but if we learn to listen in time with the unfolding of music being made, we begin to sense an ethereal quality to the experience. This is sometimes accompanied by the exhilaration of dematerialization, of entering into a kind of nonphysical space, a dream space, and Gould in an almost trance-like state can be seen playing that space, turning the material into

the wonderful, sound into art. Being in the time of that music, his body resonates, all too audibly, with the art he creates. Consequently what we are privileged to hear is the sound of being beside one's self, ecstatic joy. Art's wonder.

What I am calling the physical impress of the performer is more often thought about in a slightly different way. Indeed, the metaphor that more commonly springs to mind is of a conduit or lightning rod: as if the player seeks to integrate seamlessly his or her own person with both the sound produced and the instrument itself, thereby acting as a kind of "live wire" between us, the listener, and the score. It is almost as if the body of the performer itself becomes an instrument, instrumental in realizing the music (this is particularly noticeable in players of reed or stringed instruments). In this way the performer resonates, as it were, with the intentions of the composer and brings into sound what otherwise remains a set of inert notations. What we hear, then, is most commonly understood to be the music the performer hears. Indeed, the performer sets out to minimize as far as possible the discrepancy between what he or she hears and what the audience hears: nothing is supposed to get in the way of the most efficient transport of the music from the composer's imagined sound world to the attentive ear of the listener. Yet with Gould, whose entire being was profoundly musical, there is a sense that what we hear *is* somewhat different, as if his being comes *between* the notes in the score and their realization at the keyboard, and this presentation of being is nothing if not intensely tactile in the sound itself. Once again I want to insist that this is not only a product of his exceptional pianistic skills or eccentricities, still less a facet of his sometimes distinctly unusual, not to say wild, interpretations of specific musical works. It is that difference that prompts me to ask, "What is the correct distance to take to this music, Gould's *Goldberg*

(1981)?" And is that distance a corollary of Gould's physical disposition at the keyboard?

IT CANNOT BE ACCIDENTAL that in my chosen example Gould is playing music written by J. S. Bach; indeed, I am far from the first to note that the "fit" between the musical intelligence of the composer and the performer is almost uncanny. Gould, as audiences in the Soviet Union remarked after his 1957 concerts in Moscow and Leningrad, sounded like a 200-year-old pupil of Bach himself. Gould not only heard the world polyphonically but thought contrapuntally. This is why his performances of the late eighteenth-century and nineteenth-century repertoire—the music of Beethoven, for example—sound so strange (he disliked the truly "romantic" composers, although he did record Liszt's transcription for piano of Beethoven's sixth symphony); he was unable to prevent his musical being from interfering with what he heard. Yet what he heard, in Brahms or Beethoven, was so elementally musical that it is impossible to dismiss his realizations as merely or willfully eccentric.

Perhaps the most distinctive quality of his playing is its clarity: its clarity of thought, of organization, of exposition. What we hear in his playing in almost other-worldly clarity is the architecture of the music laid out before us: we hear the intentional organization of sound, its formal structures, as a kind of ground bass underpinning the sensation of witnessing the temporal process in and through which this sound comes into being as the art that is music. As a result, Gould's realizations can be very unforgiving—laying bare the imperfections of a piece along with its wonder. Some would argue that he introduced such imperfections through the eccentric decisions made with regard to tempi, voicings, and so forth. But I think that such comments miss the point in Gould's playing; they assume

that the player may add or subtract specific "styles," decide to play at such and such a tempo, as if the music were distinct from or lay behind these "embellishments" and interpretive decisions. But with Gould, as with every player of real integrity, the sound he produced has a direct relation to how he heard the music. The recordings of Mozart's piano sonatas, for example, which are usually understood to be among Gould's least successful—he played both the A minor (K. 310) and the C major (K. 330) at amazing speed, while playing the opening of the A major (K. 331) so haltingly that it can only be understood as a musical examination of the concept of hesitation— are often said to be eccentric beyond recognition: they do not sound like Mozart. At least they do not sound like any other recorded Mozart. But Gould, though professing a considerable affection for the early Mozart, thought his later work, that produced after the composer was eighteen or so, theatrical. This was how he *heard* these works, and his distaste for theatricality undoubtedly comes through in his playing. What you get with Gould is what you hear, and what you hear is the imprint f his extraordinary musical intelligence.

That intelligence was undoubtedly grounded in a cast of mind and discipline of the body that most players can only approximate. Gould could read music before the alphabet, and his musical memory was so prodigious, so accurate, that he could recover not only the piano part of large and complex musical works—say, a concerto for piano and orchestra—but all the other parts as well. It is almost as if Gould's hearing was eidetic, and furthermore in something like sixteen track. Whereas less gifted individuals hear one thing at a time, Gould seemed to be able to hear any number. This is why his particular musical intelligence was so suited to polyphonic and contrapuntal music and why the incredible clarity of his playing Bach is so much to the foreground of the sound. This strange training of the ear was coupled with what Edward Said calls his "truly rare digital

mechanism,"[1] which enabled him to play the contrapuntal music of Bach and others as if not only each hand but each finger contained its own musical independence. Other pianists have such technical gifts—as Said remarks—but few, if any, deploy these gifts so single-mindedly. Gould could do anything at the keyboard; he could play a vast range of the classical keyboard repertoire, from Gibbons to Schoenberg, from memory, an accomplishment unusual in contemporary concert pianists, who tend to make their careers by specializing in a restricted repertoire. And not only did he command this music "internally," as it were, know it by heart, but he could also "play by ear" almost anything and, if he so wished, make anything he played sound like anything else. This overwhelming musicality is marshaled in his realizations and enabled him to play as he heard, with a truly remarkable clarity.

Gould told an anecdote about that hearing that has subsequently become quite well rehearsed in the literature on the pianist. In 1946 he was practicing a fugue by Mozart, K 394, when his maid turned on a vacuum cleaner. Its sound interfered with the sound of the piano, which meant that his sensation of playing was more than usually based in the tactile. This effect was far from harmful, as he commented: "I could feel, of course—I could sense the tactile relation with the keyboard, which is replete with its own kind of acoustical associations, and I could imagine what I was doing, but I couldn't actually hear it."[2] He found that rather than inhibiting his ability to "hear," such distraction, if anything, enhanced it. Subsequently, if he needed to get the sense of a new score quickly, he would simulate the vacuum cleaner by "placing some totally contrary noises as close to the instrument" as possible. The TV, Beatles records, or whatever was at hand would suffice, since "what I managed to learn through the accidental coming together of Mozart and the vacuum cleaner was that the inner ear of the imagination is very much more power-

ful than is any amount of outward observation."[3] In other words, he had learned the value of inattentive listening.

If this is how Gould heard, what does his playing sound like? Generalizations will not be particularly helpful here, since Gould, like every other player, did not approach each and every piece of music in the same manner. Nevertheless, a few common traits can be isolated before I turn to the example of his second recording of the *Goldberg Variations*. Perhaps the most obvious characteristic of Gould's sound is not his pianistic skill but his vocalizations, the humming and singing that accompanies his playing. Gould was far from the first concert pianist to sing along as he played—indeed, many performers at the keyboard spontaneously erupt into *sotto voce* accompaniment: the contemporary pianist Keith Jarrett would be a good example. In the field of jazz or modern improvisation this secondary form of expression is usually tolerated—such sounds are rarely those of trained voices—but in the classical repertoire humming and vocal expression are commonly taken to be distractions from the sound of the instrument. In Gould's performances there is, however, no embarrassment about the noises emanating from his body; these sounds are an integral part of the music he made. He commented on this in the liner notes to his Mozart Sonatas recording, in which he presented a fictional dialogue between himself and the composer. He writes: "And before you ask, I always sing along with the music when I'm playing the piano. To me it's not a valuable asset, it's just an inevitable thing that has always been with me, I've never been able to get rid of it."[4]

For Gould, then, this strange sound of the body was just an "inevitable" thing, something that comes along with the music, but what is the listener supposed to make of these noises? In his playing of Bach, for example, he often sounds as if he is deliberately adding timbre to a particular sound, or calling attention to his playing a

phrase in a certain manner or style. He adds the sound of his breath, as if the instrument were capable of being blown as well as struck. It is almost as if the involuntary addition of the voice is an *inevitable* condition of making music, as if the philosophical argument that is music needs the articulation of the human voice. There are many moments in the 1981 recording of the *Goldberg Variations* when this vocalization takes on the sound of the spirit, for example, in Var. 2 or Var. 4. On other occasions there is almost a *tangibility* to the sounds he makes, as if he were fingering a stringed instrument. Once again the effect is to heighten the listener's sense of physical presence: Gould is physically agitating the instrument that helps make this music, and that instrument is not only the piano but also his body. From time to time it sounds as if he is attempting to ward off suffocation, struggling for air, whereas at other times the addition of the voice or sound of breath is more exuberant, as if he derives intense pleasure from fingering his musical intelligence and stimulating himself to new heights of ecstatic playing. For some listeners it is precisely this onanistic register of his performance that distracts from the realization of Bach's score.

On yet other occasions Gould's vocal accompaniment gives the impression of someone playing for himself, alone with the music and the instrument, and the sense we have as listeners is of *overhearing* something private. This feeling of being in a private place, of being present without having been noticed or even invited, is increasingly in evidence as Gould's visits to the recording studio came to punctuate a life lived in almost complete physical seclusion. Some of the last recordings he made, for example, those undertaken in October 1980 through March 1981 of Haydn's late sonatas Nos. 58–62, display this quality very well; it is almost as if we are eavesdropping on something hauntingly private, strange, and mysterious, alchemical even. And indeed we are: we are eavesdropping on music

being made, given access to the sound of ecstasy. This was the term Gould himself used to describe what he considered to be an authentic musical experience. Consequently, the listener is sometimes nearly forced into the position of the aural voyeur, overhearing some private transmutation of sound into music, skill into art. Hence the return to the question with which I began, What is the correct address to take to music, to this music? How may I listen with propriety?

A common enough answer to my question would be, open your ears! But in a peculiar way, precisely the opposite is really needed. Unlike our eyes, our ears can never voluntarily be closed, and this says something about our learning to close out the sound of the world, to listen *inwardly*. The art that is music may help us to learn this skill, be an aid in our attempts to close our ears. Counterintuitive as this might seem, its usefulness can be explored by returning to my comments about the phenomenology of attention-inattention. If we wish to attend to a piece of music, say, Gould playing Haydn's late piano sonatas, we must learn to listen inattentively, that is, to prevent our attention from being caught up in any one thing in the aural world around us. This might feel like intense concentration on the sound we hear, extreme attention to one sound to the exclusion of any other sounds around, but in fact that kind of attention blocks the music, prevents it from emerging; it distracts us because our attention has been sent to the wrong place. In order to hear music affectively, we must stand outside the physical space we currently occupy—indeed, we must attend so intensely to closing our ears that we begin to hear inattentively, inwardly. This feels like an emptying out of listening, a refusal of the sound we hear in order to let music in. Such voiding is connected to the sense of weightlessness that can be heard in Gould's playing, which seems to allow the sound its own space, allow it to float free of the material from which it is made.

In my attempts to direct attention to the *aesthetic* experience of music I find it necessary to unlearn my routine habit of listening in order to hear more clearly what lies ready at hand, thereby enabling the inward ear to hear the quiet but insistent sound of music's breathing—learning to listen in time with music's unfolding. As mentioned, this sense of time, of listening in time, is derived from one of the basic building blocks of music, its articulation of the temporal. Indeed, we might go further and note that in listening with music we diminish the distance between it and us, thereby bringing into the same orbit our own sense of being and music's being in time. Such experiences are rare, need to be worked for, prepared for, and they do not, necessarily, always come upon us when requested. Nevertheless, we may reach to certain works before others in the search for such experiences—some on account of their familiarity, others because of their particular qualities—and for me one such exemplary work is Gould's recording of Bach's Prelude and Fugue BWV 895. This recording, along with many of his other Bach recordings, helps me direct my attention toward my affective experience because Gould's realization of fugal structures so strenuously brings into the foreground the time of the music—a time that is distinct from clock time and the time signature or pulse of the score notation. By doing this, Gould highlights the temporal materiality of music, thus enabling the listener in his or her attempts at entering into the ecstatic space created by the performer, and this leads one to notice the discrepancy between the clock time of the world and the time of the music. In this way, being there with Bach/Gould, in the music, requires the listener to relinquish a sense of being here, in the moment of listening. This is why in "ecstatic" experiences of listening to music we feel as if we have left the time of the world—the sensation that we are alone with sound, move with it, inhabit its own

space, are a breath away from the thaumaturgy of art—and we enter into another way of experiencing time.

In this hearing of the inward ear, duration has an eccentric relationship to passing time because our sense of the time of the world, clock time, is interfered with by our listening in time, with music. I hear this most intensely in Gould's rendition of Var. 14 of the *Goldberg*. Compared with, say, Andras Schiff's 1983 Decca recording of the same piece, which blurs the pulse of the music in its looser and softer—more affecting in some registers—approach to the rigidity of Bach's formalism, Gould's interpretation is clinically cold.[5] But that coldness does not detract from the extraordinary sense I have of listening in the time of the music. And here I glimpse a sense of what it might be to play and listen at the end of time, where time runs out into something else, say, clear light.

This raises a whole set of questions that bear upon the nature of time and music. What is it to keep time in music? This is not simply a matter of aligning each musical event with its partners or associates—not merely a function of sounding notes at the right moment. Nor is it only a function of playing at a regular beat—of "keeping up" with the tempo. Both of these things are familiar to anyone who plays music, but there is something else, something more internal to the art of music, that I wish to address. This is more like the philosophical entail of music's keeping time or, to put it another way, the philosophical argument music makes about the relationships between time and being. "Keeping time" contains the sense of keeping something close, as if time were precious, valuable—as indeed it is given that it provides the ether within which music is made. But it also contains the sense of keeping up, being correctly in step. "Time" here is music's own, its peculiar take on the time of the world, clock time. Music has its own temporality; it inhabits the

interference between linearity, the sequence of sounds that is one of the preconditions for music, and musical structure, the vertical architectonics constructed in the relationships among rhythm, harmony, interval, and so forth. In this interference a timeworld is fabricated that has its own sense of duration and speed, of elaboration, repetition, stasis, and movement. Consequently, though music does not tell the time, it does tell time how to be.

It is quite clear that this timeworld has a relation to clock time but is not coincident with it. Gould believed that specific pieces of music had specific times, by which he did not mean time signatures. This is why in his second recording of the *Goldberg* he attempted to play all the variations as if they inhabited the same timeworld, had, in the term he used, a common pulse. This has the effect of minimizing the distinction in tempo between variations in order to gain greater clarity in the overall structure of the piece. Such a way of playing sometimes highlights the tension between clock time and musical time, a kind of playing against time. I think one can pick this up in Gould's furious pace in certain well-loved compositions in the classical keyboard repertoire; he seems to be playing as if he wants to catch time out so that clock time and musical time come to inhabit the same temporal sphere, the same time zone. For similar reasons, Gould selected what are usually deemed to be exaggerated time placements—some pieces played astonishingly quickly, others so slowly that the piece almost trembles at the point of disintegration—because he wished to slow to a heartbeat the sound of music coming into being. Gould thereby pushes the temporal envelope to the extreme in order to gain greater access to his realization of art, and this enables the listener to move in step with art's coming into being, breathe in time with music's being.

Contrapuntal music is ideally suited to the production of this kind of listening experience since attention is continually moving in and

out of attentive-inattentive states; we listen to the often rapid inter-
play between parts, and the sensation we have of hearing two, three,
or sometimes more voices at once intensifies the sense that our atten-
tion is being dispersed. Other forms of the Western classical tradition
produce the same or similar effects, but the keyboard music of J. S.
Bach exploits this characteristic of musical attentiveness most consis-
tently. Within that repertoire the *Goldberg Variations* have a special
place, for their musical structure is less dependent on straightforward
melodic variation than on a series of what Bach called *Veränderun-
gen*—literally, "alterations"—which are based in yet more basic
building blocks of the Western classical musical tradition: rhythm or
time scheme and interval or pitch relations. Furthermore, the over-
all structure of the piece is carefully patterned: it consists of an aria of
thirty-two bars, followed by thirty variations, and finally a repetition
of the opening aria—thirty-two pieces in all. The basic length of
each piece conforms to the thirty-two bars of the aria; in four cases
(Nos. 3, 9, 21, and 30) this is reduced to 16, and in one case, the
Ouverture (No. 16), it is increased to 48. Within the cycle itself there
is a further subdivision halfway through the work at the *Ouverture*,
and within this structure a further pattern can be discerned in the
grouping together of the first three pieces, the last of which is a
canon. This pattern is followed throughout (so that variations 3, 6, 9,
12, 15, 18, 21, and 27 are all similarly in canonic form), with the inter-
vallic scheme of each successive canon being determined by a simi-
lar adherence to serial form: No. 3 places the canon at the unison,
No. 6 at the second, and so on, through to the last, which places it at
the ninth, which is thus the ninth canon of the series.

It is this careful attention to pattern-making in the construction
of the score that Gould highlights in his musical realization, and
this results in our hearing its structure in greater clarity than in
most other performances (Rosalyn Tureck's would be an exception;

indeed, Tureck's precise and rigorous performances of Bach were very influential for Gould's own interpretations). We not only mentally visualize the pattern of the sound but also *hear* the visual pattern—this is also extremely evident in Gould's realization of book I of *The Well Tempered Clavier*. It is not only this sense of structure that I want to emphasize—indeed *hearing* structure is only an aid to the end-point of this listening experience—but also the way in which Gould's virtuosity at the keyboard helps us enter the timescape of this music. It gives us access to the there of art, to being in the music we hear, and this in an ecstatic transformation of our sitedness helps us to feel more acutely our sense of being here. What I am attempting to describe is the sense of being taken in by music, being admitted to its world, and if the listener runs the risk of being duped, "taken in" in another sense, then this is the price extracted from us if we hold out for the beauty that is art.

This is why Gould's playing radiates a sense of presence, not only of his own physical presence at the keyboard, but of the presence of art. His entire life was given over to the pursuit of wonder or, in the term he used, "ecstasy." Such a life-long project has its dangers; pretentiousness, for example, sometimes hovers close to the surface of Gould's writing. But in his playing the total commitment erases any sense of pretension. In this regard Gould was careful to plot the course between ecstasy, which for him was controlled, not without structure or purpose, and abandonment, which, again as far as he was concerned, amounted to the abdication of intelligence. Those who play with abandon have given up too much to the music they hear. Abandonment, as it were, to the power or force of the music results in an erasure of presence, as if the performer seeks to eradicate person, the physicality of *this* person, this player, in order to allow the music in. It was Gould's insight to realize that this only

blocks the sound of music. In Gould's playing there is always a controlling intelligence at work, indeed, this might be called one of his signatures. Thus whereas in one sense he is constantly present to his performances, whether in the recording studio or on the concert stage, in another he is curiously absent, as if his attention is focused on anything but his own presentation. He is both the most flamboyant and annoyingly showy—even egotistical—classical performer in recent recording history and at the same time the least egocentric.

Of course it could be remarked that very intense levels of concentration are required of any concert pianist in performance, but the performer need not necessarily be attentive in the usual sense. Although a player must concentrate and prevent him- or herself from being carried away by the music, such concentration need not be *on* what is realized at the keyboard, on the sound one makes. Gould's remarkable technique enabled him to exercise the complete and constant physical control necessary relatively easily, and it is this control that allowed his attention to become inattentive, thereby opening up the possibility of our hearing along with him—eavesdropping—on the sound of music being made. As the anecdote of the vacuum cleaner suggests, such inattention involves listening otherwise, listening somewhere else. On video Gould appears both intensely absorbed, acutely self-present, and, curiously, almost lacking in presence. He appears to be both listening elsewhere and almost without the capacity for hearing, almost deaf to the sound he makes: lost in wonder. The spirited and pretty much continual accompaniment—both vocal and physical in the waving of arms or chewing of the jaw—seems to be based in a profound indifference to the sound he produces (and for this reason he was similarly indifferent to the *sound* of the instrument he played, stressing instead the importance of the *action* of the keyboard). This, I think, distinguishes

Gould very markedly from other performers, who, in Gould's terms, are too caught up in their own sound: they are attending to the wrong thing. For Gould this is why the virtuoso's narcissism is deafening; it defeats the quiet rhythmic breathing of sound being transformed into music. Compare, for example, Gould's 1981 recording with that by Andrei Gavrilov (DG 435436-2); in the latter there is too great a reverence to the notated score, as if Gavrilov is afraid to touch Bach's music.[6] It's a playing of rspect, of keeping a distance, that is apparent in his approach to the note; it is as if he slides up to it stealthily, almost fearfully, afraid of allowing music its own time or being. Curiously, the touch of his fingers is too delicate, hesitant in its release of the key, the approach too genteel, and this results in what to me sounds like too great a distance from the music. To put it another way: the music I hear remains curiously inert.

What I hear in Gould's second recording of the *Goldberg* is the sound of clarity, of coming into a clearing, open space. On occasion this is accompanied by a corresponding sensation of lucidity, perspicuity, clear-sightedness, and when this happens I feel as if Gould's playing has the capacity to clear my mind. But this feeling is merely an adjunct to my affective experience proper, which opens up to me something I perceive to be *in* the artwork, its material. The best word I can find for that is *clarity*. In Gould's recording of Haydn's last six sonatas I find a similar but nevertheless distinct material to my affective response, what I would call vividness, whereas I find something like transparency in my response to his rendition of Mozart's first six piano sonatas. In all these cases these terms are intended to describe what lies between my own feelings and what I perceive to be internal to the works themselves. Transparency is a way of knowing known, as it were, to Gould's rendition of Mozart's first six piano sonatas. And rather oddly this way of knowing—transparency, say—is curiously indifferent to the fact that its knowingness cannot be translated into

propositional knowledge. While I recognize this, know it by another route, I also continue to feel that such knowing is shareable, knowable to others.

What I am calling clarity is, for sure, connected both to the music Bach composed—the contrapuntal organization of sound that weaves lines in and out of one another all the time—and to Gould's realization, his creation of this music. Paradoxically, clarity emerges even while my attention is displaced across a range of musical elements: the structure of the entire piece, the structure of specific episodes within the whole, the movement of a line from left to right hand and back, the tension produced by differing time placements—indeed, the entire punctual aspect of Bach's score.

All this claims a kind of general attention so that I can hear more than one thing at a time, listen not only to the primary melodic line but also to its fugal displacements, or harmonic variations, and so forth. In this way my learning to hear this music is attendant on an almost total somatic presentation: I must learn to listen with more than my ears—this is why I find an intensely visual aspect to my hearing Gould play Bach—in effect I must present my body to this sound, feel it resonate, press it up close, in order to hear the music Gould made. Although I can intellectualize this form of listening as a kind of general attention, as if there were no one place where I can direct my attentive ear, it does not feel quite like that since I have the strong sensation of being constantly seduced into exclusively following one aspect of the sound. It is as if my ears have been locked into one line and its variations, and I hear this against all that counterposes it, be it rhythm, melody, harmony, or something else. But once here, in the clearing of a single line of articulation, I find my attention drawn—almost against my will—to another aspect. Consequently, my listening ear must constantly readjust itself, sequentially tuning in to the discrete sounds that are woven together

in the overall soundscape of this composition. Such a movement of attention, the constant retuning of my listening frequency, prevents an attentive, dedicated listening activity from developing. This feels as if I am emptying out my hearing in order to let something else be heard, stilling the sound of my own body, the comfortably gloved rhythm of suspiration, in order to sense the possibility of breathless wonder that occurs when I let the music in. The distance I need to take to this music, then, is as close as I can manage.

I think this playing can be understood as a philosophical argument: it states a case for a particular way of being, for a particular proximity to being. It could be said to present the perspicuity of being. Gould's decision to play all the variations according to what he called "a common pulse" has the effect of exaggerating speed at both ends of the spectrum: some sections are played with such intensity, skill, and dexterity that the listening ear becomes breathless in its attempts to keep up, while others are slowed to a rhythmic suspiration that runs the risk of arresting the necessary onward pulsion of music's unfolding in time. If almost any other performer, with the exception of Rosalyn Tureck, attempted this, the risk of the music's disintegrating would be too great; the music would all but disappear as a single sound threatened to become, like a frozen film still, a shard of the shattered whole. But Gould's profound understanding of Bach's writing, coupled with his exaggerated musicality—the digital skill and complete immersion in the technical mechanics of the keyboard, not to mention the fact that he knows by heart great swathes of the Western musical tradition—allowed him to embrace even this, potentially very damaging, possibility. And this gives added emphasis to the philosophical argument presented by the *Goldberg*—it opens up the deep structure of music's being in time.

Many examples from Gould's 1981 recording could be furnished
here, but I will select just one. In the very opening of the work, the
aria that will also close the entire set of variations, Gould allows the
argument to come forward in a daring but beautifully nuanced way.
The first thing to note is the speed at which Gould chose to play—
d = 60, the speed of one pulse per second, in a sense the equivalent
of a rhythmic middle C—since this sets an unusually slow pace for
all the variations (Gould's 1955 recording, for example, lasts a little
more than half the time of the 1981 recording). The aria begins on
the note G and is in the key of G major; this G will also end both the
aria and, as the last note, the entire piece. The music starts quietly,
unemphatically. Listeners acquainted with Gould's earlier 1955 re-
cording immediately discern a different feel to the sound. Then, in
the eleventh measure, Bach's score indicates a chord to be arpeg-
giated, in fact the only such marking in the entire piece, and accord-
ing to prevailing keyboard conventions, the norm would be to sound
the notes in ascending order. Gould does not do this; he isolates the
top G before descending through the lower notes E, B, and G, and as
he does so he keeps the strings open by holding the sustaining pedal
down. The effect is to suggest a suspension of the top note as the har-
monics set up by sounding the third and sixth intervals of the chord
are produced when Gould keeps the keys depressed. At this moment
the pulse of the music is suspended and one senses the possibility
that the complete fabric of the work might now, at this moment of
resonance, be held in the hand, as if the entire piece might possibly
be distilled into this one sound. Time both stands still and is elon-
gated into the dying reverberations of the harmonics around G. It is
almost as if that sound carries within it an imprint, trace, or memory
of the whole. For me this suspension has an intensely visual aspect to
it, as if the aural suddenly breaks into color. Another way of putting

this would be to note the compelling sensation of finding oneself located in an aural world that has a very distinct physical presence, a place that I characterize as a clearing at the end of a chord and its harmonic resonation, the clear light at the end of time.

Although other players at the time Gould first came to prominence made the same interpretive choice vis-à-vis the arpeggiation—it may have become a kind of mini-convention—I am not aware of any recording other than Gould's that gives such fragile beauty to the sustaining of the top G in this chord. Although Gould's own 1955 recording for CBS and the more recently released live performance at the Salzburg Festival in 1959 (Sony, Glenn Gould Edition, SMK52 685) both feature him playing a descending arpeggio, the affective register does not seem to me to be the same.[7] This is partly on account of the speed of both the arpeggio and the overall tempo selected by Gould for playing the variations, but only partly. I think it is quite clear that Gould intended to foster a particular affect by playing the arpeggiation in this way—it was not an unthinking repetition of a convention—and this is corroborated by his decision to play an ascending arpeggio in the aria da capo, that is, when the chord appears for the second time at the close of the variations. Although a quick survey of recent recordings demonstrates a lack of consensus with regard to how the chord should be sounded—Andrei Gavrilov in his 1993 recording ascends through the arpeggio while Andras Schiff in his 1983 version and Rosalyn Tureck in her 1988 recording both descend—Gould's choice to descend is not the only characteristic that I find noteworthy.[8] Indeed, equally significant is the particular resonance he gives to the top G. A comparison with Tureck here is germane since her realization is the closest to Gould's, though it should be noted that she does not isolate the top note at all.

All this points toward a very conscious articulation, a deliberate emphasis placed upon Bach's score. The way I read it, that emphasis is placed on the elemental architectonics of music as an art form. Gould's signature is everywhere present in the 1981 recording, but his prompts toward ecstatic being do not come any more openly than at this moment at the start of the eleventh measure of the aria. Here the making of the art that is music appears both shimmeringly beautiful and regrettably evanescent.

I would like to conclude by attempting an account of the final minutes of Gould's reading of Bach's work. In a number of the final variations I have a sense of muscularity, as if the music is becoming more strenuous, and this alerts the inward ear, makes it listen up. It is almost as if hearing itself becomes tense, expectant. This is especially evident in variation 26, where the sound bristles with pent-up energy, almost screaming for some form of relaxation. The effect on the listener is to intensify expectation, magnify the craving for release, causing a suspension in ourselves, a hiatus or momentary lapse of breathing. This is not unlike the moment before catching one's breath in preparation for one last superhuman effort. Like the moment before descending below the surface of the water. In the variation that follows the desired relaxation is provided and one is able to breathe more comfortably once again; the sense I have is of coming up for air from the depths of the artwork. And then, in this moment of suspiration, I notice that the previous variation is being opened out, elaborated upon, presented in a more expansive form. And being this close up to the music, I hardly register the sound of breathing that has returned to Gould's own voicing of the music. By variation 29 the hesitant and slightly panicked searching for air has vanished; in its place is a sense of mastery, of the rhythm of being beating out its time signature. The sound is absolutely confident, a

sound of being at one: being here, in this music, presents an intense sensation of clarity, and I find myself in wonderment.

Bach's score has yet to be fully realized, however, and the opening aria returns as a way of completing the formal structure harmoniously. This feels like a kind of spiritual warming down; the exertion of the 30 variations needs this moment of reflection, a subsidence into silence. Here the body learns to feel the burn of exercitation; the music is balmy, it soothes, it quiets, it is there to confine agitation, to refocus attention on the inattentive unintentional act of rhythmic suspiration. In the main body of the work, being with this music feels like expense, exhilaration caused by exhaustion; many of the variations are near to breathless wonder. Now at its conclusion, near exhaustion, the ear and body crave what they already know, their own quiet sound of exhalation. All attention is now spent, all breath has been breathed, yet what I hear is the slow, regular sound of inspiration. I am attending to my breathing, keenly aware of the transformation that takes place in the air I breathe in and then expel, physically attuned to the transformative power of art. And I am as close up to this music now as I am to my own breath. Gould, and through Gould, Bach, teach me how to breathe life into this experience of the art that is music, and, in a sense that only I can have, only the listener can experience for him- or herself, it takes the breath away.

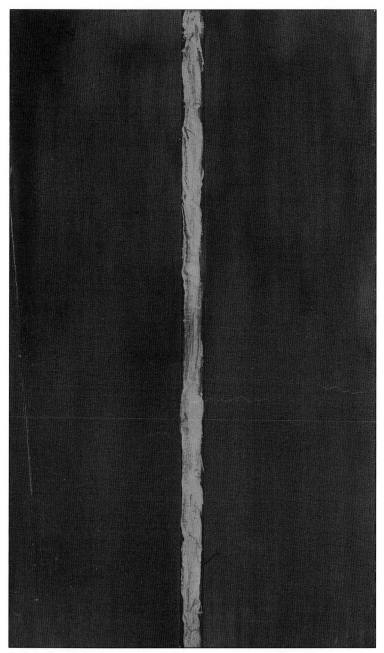

Figure 3. Barnett Newman, *Onement I*, oil on canvas, 27¼" x 16¼", 1948. Museum of Modern Art, New York. Gift of Annalee Newman. © ARS, NY, and DACS, London, 2001. Photograph © 2001 Museum of Modern Art.

Figure 2. Marc Quinn, *Self*, detail. The Saatchi Gallery, London.

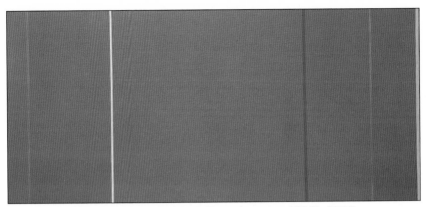

Figure 4. Barnett Newman, *Vir Heroicus Sublimis*, oil on canvas, 7'11 ⅜" x 17'9¼", 1950–1951. Museum of Modern Art, New York. Gift of Mr. and Mrs. Ben Heller. © the artist. Photograph © 2001 Museum of Modern Art.

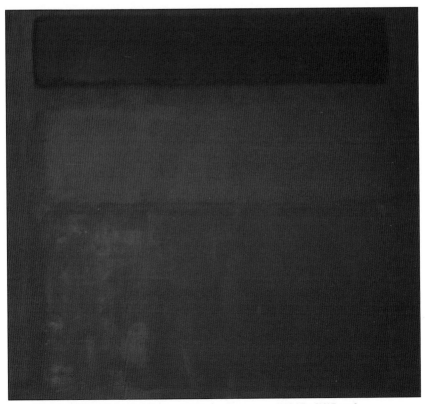

Figure 5. Mark Rothko, *Red, Brown and Black*, oil on canvas, 8'10 ⅝" x 9'9¼", 1958. Museum of Modern Art, New York. Mrs. Simon Guggenheim Fund. © the artist. Photograph © 2001 Museum of Modern Art.

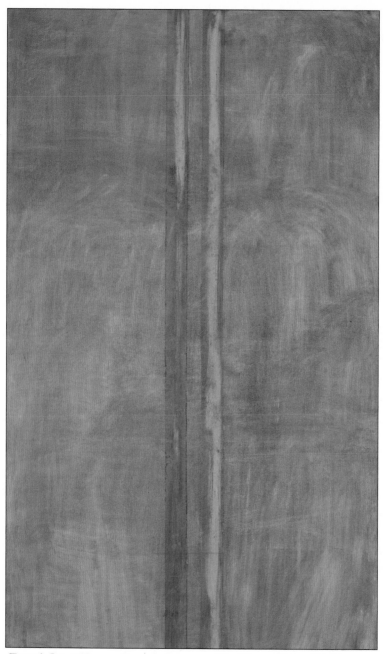

Figure 6. Barnett Newman, *Concord*, oil on canvas, 90" x 54", 1949. Metropolitan Museum of Art, New York. George A. Hearn Fund, 1968. © the artist. Photograph © 1997 Metropolitan Museum of Art.

Figure 7. Barnett Newman, *Cathedra*, oil and magna on canvas, 96" x 213", 1951. Stedelijk Museum, Amsterdam. © ARS, NY, and DAC, London, 2001.

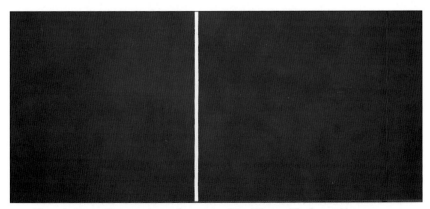

Figure 8. Barnett Newman, *Argos*, oil on canvas, 33" x 72", 1949. The Barnett Newman Foundation, New York. © ARS, NY, and DACS, London, 2001.

Figure 9. Barnett Newman, *Dionysius*, oil on canvas, 69" x 48", 1949. National Gallery of Art, Washington, D.C. Gift of Annalee Newman. © ARS, NY, and DACS, London, 2001. Photograph © 2001 Board of Trustees, National Gallery of Art.

Figure 10. Barnett Newman, *Who's Afraid of Red, Yellow and Blue IV,* acrylic on canvas, 108" x 238", 1969–1970. Staatliche Museen zu Berlin—Preussischer Kulturbesitz Nationalgalerie. © ARS, NY, and DACS, London, 2001.

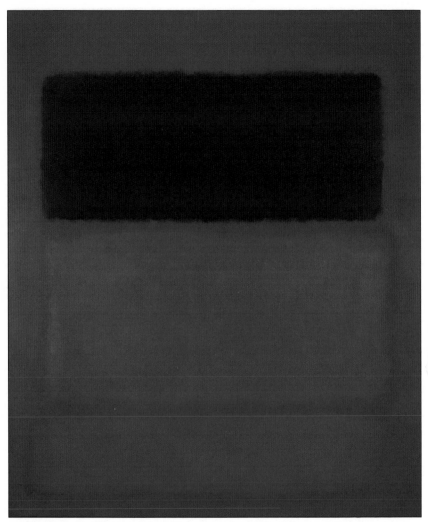

Figure 11. Mark Rothko, *Black over Reds*, oil on canvas, 95½" x 81½", 1957. Baltimore Museum of Art, Baltimore, Maryland. © the artist.

4

Equanimity: Wordsworth's *We Are Seven*

T HIS CHAPTER SETS OUT TO EXPLORE an affective response to a work of literature. It may seem banal to note that in the case of artworks made of language we must first read them before we are able to say anything at all about a response. But this fact has serious and complex consequences since an affective response may develop simultaneously with the production of the work itself (literary works of art are produced in the activity of reading). Thus to a greater degree than with the sister activities of listening and looking, reading is an interventionist activity: whether we like it or not, reading necessarily encompasses the making of meaning. Though it might seem logical to read a literary text before attending to an *aesthetic* response to it, in fact, this is impossible given that the reading and the response are interactive; that is, one develops in the shadow and in step with the other. An exploration of affective experiences of texts, therefore, must go hand

in hand with the production or presentation of a "reading" or interpretation.

This is not always an easy task—establishing a reading may be both time-consuming and difficult. It is certainly the case that much commentary on literary texts either sets out to do no more than present a reading or stalls, often in exhaustion, at the point where a reading has become established. (In the case of some notorious texts this is more a hope than an expectation.) In this chapter, by contrast, I will attempt to go beyond (or better, go beside) a reading in order to open out an *aesthetic* experience of a text. Nonetheless, this will necessitate the presentation of a reading as well.

In attempting to elaborate a specifically *aesthetic* response to a text, it is useful to bear in mind that in the course of the process of reading, certain questions—or prompts—may be more helpful than others. I have found that when teaching students how to progress in the elaboration of their responses, the question "What are you asking yourself?" often helps them to prevent a reading from stalling or, when stalled, to get started again. Of course one needs to know here which questions or forms of question are appropriate in the face of a text. What can we ask *it*? Unfortunately, this task becomes complicated rather quickly when one begins to consider how particular responses may or may not be intelligible as, precisely, answers. Another way of putting this would be to note that we need to investigate the specific address we take to a particular text; that is, we must ask about the propriety of one address or another and, consequent on that, about the source of such propriety. Indeed, as will be shown, this issue of propriety goes to the center of many contemporary disagreements about the reading or interpretation of literary texts. Moreover, for some the very cause of disagreement lies in the assumed validity of the notion of "propriety" itself: such readers hold to the view that authors have no rights with respect to the readings

we make. Texts, they contend, may be read in an endless variety of ways, and readers are no more bound by a sense of "propriety" than they are bound by authors' intentions. Furthermore, in holding to a sense of the "proper" one is mired within a set of expectations and beliefs—in ideological positions—to such an extent that any reading can only reiterate the grounding ideology. Contrary to this kind of argument, I do find it helpful to bring to mind the issue of propriety because it keeps the distinctiveness of the text firmly in view, which is to say that it helps me return to what both promps and contains my reading. It gives me a handle on answering the question, "What feels right (in the case of *this* text)?"

Reading is a far more risky business than is often assumed, or that we care to admit, but it is said that there is often scant reward where there is no risk. The risks I have in mind concern our ability or willingness to open ourselves to a text—which can certainly be as risky a business as opening ourselves to another—that is, to acknowledge that the text might know what we, as yet, do not (or could not), and that knowing *this* (acknowledging it) is bound to be either beneficial or potentially harmful to us (or indeed at different times both). It is the argument of this book that such acknowledgment could only result from an *aesthetic* experience of the text, hence the following attempt to push past a reading of a poem into the clearing of an affective encounter. Put in a slightly different way, it asks an interpretive act to reveal what it conceives of as its other, its "over there," or, to continue an earlier metaphor, what it produces by its side, its adjacency.

The text I have chosen is by William Wordsworth, and so part of my inquiry will encompass the specificity of an interpretive act in the face of a Wordsworthian text. I wish to signal an anxiety here at the outset about that specificity, a query concerning the notion that there might be something distinctive to the work that gets done in the face

of a Wordsworthian poem, distinctive in Wordsworthian interpretation. What I mean to question here is whether or not one needs a peculiar textual sensitivity in order to read Wordsworth Wordsworthianly, as it were. The anxiety stems from the fact that I am unable to settle the question as to whether the form of interpretation is necessitated by something distinctively Wordsworthian, or whether that distinguishing feature is itself the product of an interpretive act. Consequently, I cannot yet fathom what it might mean to read Wordsworthianly since knowing that would seem to be dependent upon my having read a Wordsworthian text. Although it would, of course, be more helpful if this were not so, or not exclusively so, since this would imply that one could read other texts Wordsworthianly, as if the mode of address taken to one text were applicable to others. This returns me to the issue of propriety: in thinking about reading this way, what is one trying to respect, and if one chooses not to respect such proprieties (and how much is this a matter of choice?) what are the consequences? Furthermore, in thinking this way about *setting out to read* I mean to bring to mind the observation that these choices about propriety, about what may or may not be appropriate to ask of a text, are ultimately concerned with what feels appropriate to ask of oneself. This is so even if the questions asked of texts are forms of defense or resistance to asking such questions, or similar and related questions to and of ourselves.

By beginning in this way I wish to signal that my affective encounter with the text I will read remains in something like an interrogative mood—and this is so even after prolonged and extensive attempts to settle certain issues that will be raised in the following discussion—almost as if the affective experience itself might be characterized as falling in between the demands and desires articulated by the question form. I am sure that this is caused by the poem itself, which, I will argue, hesitates at the threshold of knowing what an

answer to the question it asks might look like. In other words, what we demand as an answer in the formulation of a question may not always be intelligible to *us* as an answer, which is to say that a mismatch can occur between the questions we formulate and our desire for a particular answer.

The following reading sets out to face the fact, to acknowledge, that there is a distance between the questions we might ask of texts and the answers we might demand, and that this distance is, in one of its guises, an index to what we cannot and do not ask of ourselves. The act of reading, in this light, continuously plays hide and seek with our desire for enlightenment and our fear of knowing. In the following discussion I set out to confront both that desire and that fear, in the hope that what I have called the inherent risk in reading will become more evident.

To make this even clearer and avoid possible confusion: I am not arguing for a specific, proper reading on account of the text's being Worsdworthian, as it might be called. Rather, I will attempt to keep in mind the issue of propriety, as I test my reading against the text— all the while remaining skeptical of the appropriateness of my reading—in order to prevent the inevitable closure or consistency of an interpretation from developing. In common with my other examples, then, I will insist on there being qualities intrinsic to the artwork, here a poem, and will strive to respond to those qualities, hear the quiet murmur of the text above the noise of my own internal reading voice. On account of this I will call to mind the question of propriety quite frequently in order to test the mode of address adopted in the face of a Wordsworthian poem. What preserves my sense of the text's own being, its being a Wordsworthian text, while acknowledging at the same time that the act of reading is performed by an individual who is positioned and positions him- or herself in relation to both that act of reading and the specific text at hand?

I think it is clear that a balance needs to be struck over this matter, and part of the success or failure of the following exposition will be conditional upon how that balance is constructed. But such success or failure will also be weighed against my larger stated aim: that of pushing past this reading in order to open out my affective experience.

I would like to ward off a possible confusion here: all this could be taken to signal that I am proposing another model of interpretation, another method for reading the Wordsworthian text. Such a method would, of course, sit next to the countless modes of reading and interpretive strategies we already have—they stretch from the new critical and biographical to the structural and poststructural, from the historical to the new-historical. But this would be to miss my point, for I am less interested in examining another new interpretive model for reading Wordsworth than in asking what is within my interpretation of this text so that my affective response might become more visible to me. Thus my reading will be merely instrumental, performed as a way of getting somewhere else on the way to wonder.

It could be said that my reading will do no more than ventriloquize a voice or voices belonging to some texts encountered along the way. This act of ventriloquism is of course peculiarly Wordsworthian, a point I will dwell upon a little later, and this prompts the thought that if one may speak of a distinctively Wordsworthian form of interpretation it might be nothing more or less than an act of ventriloquism: speaking in another's voice. The first of these texts is not by Wordsworth at all but by the contemporary American philosopher Stanley Cavell. In the course of a discussion of a group of Hollywood films of the 1930s and 1940s that Cavell designates as "Hollywood Comedies of Remarriage," he notes a distinctive feature of complaints about "going too far" in interpretation. He writes:

The idea of reading something into a text seems to convey a picture of putting something into a text that is not *there*. Then you have to say what is there and it turns out to be nothing but a text . . . But "reading in," as a term of criticism, suggests something quite particular, like going too far even if on a real track. Then the question would be, as the question often is about philosophy, how to bring reading to an end. And this should be seen as a problem internal to criticism, not a criticism of it from outside. In my experience people worried about reading in, or overinterpretation, or going too far, are, or were, typically afraid of getting started, of reading as such, as if afraid that texts—like people, like times and places— mean things and moreover mean more than you know.[1]

I begin with this quote because the issue of knowing how far one can go, and how far one has in fact gone, whether or not one senses that one has arrived at the end, or at a pause, in the work of interpretation will more than once interrupt the process of my reading. Here is my chosen text:

> We Are Seven
>
> A simple child, dear brother Jim,
> That lightly draws its breath,
> And feels its life in every limb,
> What should it know of death?
>
> I met a little cottage girl,
> She was eight years old, she said;
> Her hair was thick with many a curl
> That clustered round her head.

Equanimity

She had a rustic, woodland air,
And she was wildly clad;
Her eyes were fair, and very fair,
—Her beauty made me glad.

"Sisters and brothers, little maid,
How many may you be?"
"How many? seven in all," she said,
And wondering looked at me.

"And where are they, I pray you tell?"
She answered, "Seven are we,
And two of us at Conway dwell,
And two are gone to sea.

Two of us in the church-yard lie,
My sister and my brother,
And in the church-yard cottage, I
Dwell near them with my mother."

"You say that two at Conway dwell,
And two are gone to sea,
Yet you are seven; I pray you tell
Sweet Maid, how this may be?"

Then did the little Maid reply,
"Seven boys and girls are we;
Two of us in the church-yard lie,
Beneath the church-yard tree."

"You run about, my little maid,
Your limbs they are alive;
If two are in the church-yard laid,
Then ye are only five."

"Their graves are green, they may be seen,"
The little Maid replied,
"Twelve steps or more from my mother's door,
And they are side by side.

"My stockings there I often knit,
My kerchief there I hem;
And there upon the ground I sit—
I sit and sing to them.

And often after sunset, Sir,
When it is light and fair,
I take my little porringer,
And eat my supper there.

The first that died was little Jane;
In bed she moaning lay,
Till God released her of her pain,
And then she went away.

So in the church-yard she was laid,
And all the summer dry,
Together round her grave we played,
My brother John and I.

And when the ground was white with snow,
And I could run and slide,
My brother John was forced to go,
And he lies by her side."

"How many are you then," said I,
"If they two are in Heaven?"
The little Maid did reply,
"O Master! we are seven."

"But they are dead; those two are dead!
Their spirits are in heaven!"
'Twas throwing words away; for still
The little Maid would have her will,
And said, "Nay, we are seven!"

I have encountered readers who find this poem trivial or overly
sentimental and, when not articulating deep misgivings about the
authenticity of the described encounter, often express irritation at
what is taken to be the coercive force of the poem. It is almost as if in
reading the poem one is forced to side with one or the other of the
protagonists (usually the adult). I find such responses odd, as if they
refuse to countenance the other side of the response, the obverse of
the trivial and sentimental that is open to the evenhandedness of see-
ing first one side of the exchange and then the other, thereby con-
verting the trivial into something more profound, even touching.
Such an evenhandedness seems to be echoed in the very numeric
structures that the poem energizes—the number of lines per stanza
(four except in the last, which contains five); the length of line (a
firm pattern alternating eight syllables with six except in crucial
cases: "seven boys and girls are we" [7]; "she was eight years old she
said" [7]); the accuracy of number in relation to the size of the family
(7 or 5?); the age of the girl (8); the number of steps from the door
(12—the sum of five and seven)—and in the tension that the oscilla-
tion between odd and even generates.

This tension dramatizes the difficulty of arriving at a final resolu-
tion, which in the universe of the poem would be the girl's accept-
ance of the adult's sense of the weight of words. In contrast to those
who find this poem sentimental, I find that it raises profound ques-
tions concerned with naming and numbering—of naming and num-
bering oneself as part of the world. To some extent my response to

the poem involves me in asking such questions of myself (I must, at least, confront these questions in whatever way I can). One of the things that leads me to intuit an unfathomable knowing in the poem is precisely this drive toward self-questioning that I find in my response, and part of my sense of the poem's child-like beauty—call it a deathly lack of pretension—derives from the tangible sense of my having yet to settle such questions for myself. "What should it know of death?" *feels* like an admonition from the other side, the odd universe, which I instantaneously convert into the even world of adult certainty, grown-up knowledge. But as I do this I cannot fail to register the spectral impression left by the odd thought that there might be a continuity between the world I inhabit and some other place, named in another poem by Wordsworth (after Milton) as the "nether world," in which persons dead and alive might feel one another's presence. This thought is no more odd, as it were, than the notion that I might come to know—say, inhabit—the world as described by the little girl in this poem (a notion that is common to the poet figure in the poem and forms one of the primary assumptions of the act of reading, and therefore common to the reader as well). It is certainly a part of my experience that I can, from time to time and usually at the most unsuspecting, and because unsuspecting intensely affecting, moments, sense absent persons as present. Almost as if a shadow, or smile, or laugh has been left behind by a person deeply missed andprofoundly loved. Acknowledging this is tantamount to saying that I might, eventually, know this poem in some sense as if its knowing were a property I might hold—to myself, for comfort, perhaps. I find the poem, then, far from trivial, maybe too deep for tears.

The poem itself gives us hints as to how we might go about plumbing such depths. In point of fact one way of understanding the exchange dramatized by the poem is to see it as a model or key for its own interpretation. Seen in this light any reading will swerve toward

an "over-reading" in its attempt to unlock what the text itself knows. Something like this might be called the poem's desire to reveal or acknowledge its own over-reading. And this acknowledgment of over-reading is fully grounded in the Wordsworthian idiom: it helps produce the therapeutic force of a poem such as *The Prelude*, for example; and by this I mean the therapeutic force felt by the poem itself, as if writing were a therapy for experience and vice-versa. This gives to that poem its quality of hesitant solace, its restorative power. In the poem at hand we find something similar, although refracted in slightly different ways. This I will call the burden of this poem, here glossed as the text's own revelation of itself to itself, which gives to the conversation—for that is how I will describe the exchanges between the poet/inquisitor figure and the little girl—its sense of drama, of urgency, of there being something at stake. Moreover, it is a common feature of Wordsworth's poetry to take seriously the notion that the burden of a poem is the text's own revelation of itself to itself. I think here of a poem such as "To the Clouds," or "Composed by the Side of Grasmere Lake."

If this is a conversation, what are the particular characteristics of the two interlocutors? The adult, for example, appears almost like an inquisitor whose voice conforms with and confirms a theory of meaning based within the needs and demands of the social, a kind of contractarian theory of meaning in which the descriptive phrase "we are seven" can only, or must only, refer to beings present or alive, inhabiting the same continuum as the point of speech. The child, by contrast, is portrayed as naive or uneducated; her voice sounds out the demand that language be subordinated to lived experience. Consequently, for her the meaning of the phrase "we are seven" is to be found outside the present social context of speech, its voicing in the here of the now. These characterizations of the difference of voice that is the drama of the poem chime with the observations of many

readers who, in common with Geoffrey Hartman in his 1964 account of the poem, see the confrontation in terms of the distances between the social and the individual. It is in these distances that the confusions of different assumptions about the nature of language and of language's relationship to experience are amplified, and it is taken that this reflects Wordsworth's belief in a crisis in the nature of language or meaning and its relationship to the world. Hence the project announced in the Preface to *Lyrical Ballads*. But I find that this emphasis on the social and on the "authenticity" of the girl's experience of language and the world ignores what I take to be the knowingness of the poem, instead directing attention away from the unresolved nature of the encounter.

I would like to approach that knowingness by asking what difference it might make if the child were to accept the correction of the adult: what would the difference be were the child to accede to the demands of the social, that is, to put away childish things and take on (or put on, as it were, weeds of mourning) the adult description of how the world is, of being in the world, and thereby capitulate, acquiesce in the belief that the adult's voicing of the world is more accurate (sustainable, finally believable?) than her own? What would it mean for the child to speak with the voice of the adult? What fear do we articulate in the demand that children "grow up," that is, put on an adult's voice, thereby negating or erasing the immediacy, which here is co-instantaneity, of speech and world, meaning and experience that seems to be characterized by the girl's insistence that "we are seven"?

This is, of course, to assume that the adult description of how the world *is* is indeed accessible to the child. Here I mean to invoke the difficulty of a distinctively Wordsworthian proposition, or burden, namely, the acknowledgment of the necessity that the child is father to the man. Such a Wordsworthian proposition is also, in a different

habitus, an Emersonian one in which the question of founding, a philosophy, a grammar of life, is intimately linked to finding in what Emerson calls the foundling of the child. Founding and finding are so much a feature of the sense we might have of the child that here, in this poem, the opinion might be imputed to the poet that our progression from childhood to adulthood is less a progression or growth than a forgetting or casting off. This perception certainly does not lead to nostalgia since the adult is unable to remember what it was to be a child, what knowledge or knowing is in childhood. Of course one of the principal difficulties examined by the poem is this notion that children know what we, as adults, cannot, but at the same time in order to know what knowledge is, that is, in a sense to name knowledge, demands that we have found, in both senses of finding and founding, ourselves. And this, in the language of the poem, is equivalent to the requirement that we be able to name both ourselves and the world, count on ourselves for the evidence that the world gives us. This prompts the following thought: Is it specific only to this case that the founding of self is equivalent to the necessity that naming and numbering are voiced as one? Or, rather, is this a general necessity in relation to how we count on ourselves for the "truth" of our senses? I understand this to be both a question of philosophic generality and a specific inquiry prompted by the reading of the poem I am pursuing. And that reading leads me to *feel* the pressure of the question myself—as if my affective experience entails that I find myself open to such a philosophic gneralization, open and, at the same time, unable to hide from the consequences of having posed the question to myself. What I *feel*, then, is both the awkwardness of avoidance and the release of acknowledgment—avoidance of asking myself the question of number and acknowledgment of the necessity of naming and numbering oneself as one. Perhaps this is why some readers squirm or react negatively to this poem—they feel

too insistently the pressure of avoidance, the fear of confronting a question that may have to wait some considerable time for its answer (if indeed it may ever be answered). To such readers perhaps this is already far enough—if not too far—to have gone in the work of interpretation.

I take pressure, however, as merely a first shot at elaborating my affective response to *We Are Seven*, and I want to keep on the trail by pushing harder on the distinction between knowledge and acknowledgment that I take to be a part of the poem's dramatic purpose. If the child's refusal or inability to acknowledge knowledge, as perceived by the adult, is the material of the conversation, then the poem's sense of its own burden seems to be generated by this difference in the quality of acknowledgment itself. Put more schematically, what the poem most pressingly asks of itself is its preparedness to acknowledge what it reveals, or acknowledges, to itself. Thus what this poem wants to know is not the knowledge of adult certainty— what should it know of death?—which in the poem seems to amount to the perception that to live is to acknowledge that we must die, but rather what is being interpreted *as* knowledge within the poem itself. It wants to know how something—a form of words—may count as knowledge, as a way of knowing the facts of the world, and this is not the same thing as wanting to know what the phrase "we are seven" means in the sense of understanding what its primary referent might be.

In addressing this desire and lack—its want—the poem dramatizes a mistake or error in the relationship between words and the world in order to let the work of interpretation and acknowledgment shine through. Thus it falls to the adult poet to expose the weightlessness of the child's words by insisting on their weight and demanding of them that what they mean is equivalent to what he and, he assumes, society takes them to mean, that is, to know or acknowledge

that meaning. From a slightly different perspective the child's refusal to take on board the adult description of the state of affairs is to be taken not as a childish inability to see things as they really are, as seeing only the seeming of things, as if seeming were inferior to being, still less as an immature reflection of the adult's description of the state of things, but rather as an *interpretation* of that state of things. This is how the world is, how it appears to the child, and she, for her part, makes a counterdemand on the adult, and by extension on the reader, that he accept her description of the world, or at the very least accept that there might be a way of knowing unknown to *both* the adult and the child, a form of knowing that is not susceptible to the mechanics of exchange that pertain in this case. Such a form of knowing could not, therefore, become common property, yet in coming to know *that* I do not give up on the sense that if this were a form of knowing it must also be within the orbit of things knowable and therefore shareable with others. This might be termed the burden that art reveals, or the distinctiveness of the *aesthetic*. In this respect the pressure upon the figurative status of the words "we are seven"—to the adult, of course, it is the point of the exchange to insist on the impossibility of their being anything but literal—leads to the superimposition of the literal upon the figural *as a way of interpreting* or demanding that the girl's speech conform to the state of things as they are, that seeming (as the child's interpretation of being) be equated or subordinated to seeing. This, I take it, is the force of the irregular tenth stanza, in which the rhyme "seen" is only made internally to the line in which it occurs. There is no "rhyme" in the sense of correspondence, for seeing in the world of seeming, since everything exists in a continuum produced by the act of numbering.

In another discursive context, how can one resist the sense that such an insistence on subordination is also a sublimation, a mark of

having faced the weight of being and retreated into adult certainty? In any event, this demand is given the form of words "I pray you tell" and is first connected to a question over location—"where are they?"—before going on to constitute the crux of the exchange between the adult inquisitor and the naive girl: "yet you are seven." What is secreted in the politeness of the locution "I pray you tell"? Could prayer—albeit signaled far back in the conventionalized idiom used here—be another form of this strange mode of knowing in which something is known to prayer itself but unknowable elsewhere? Are prayers in any way "tellable"? Communicable to others? They are, of course, often common property and voiced out loud in a ritualized practice designed to demonstrate our belonging to a shared, shareable world, to a community that binds us. The studied formality of the adult's politesse (a mark of his attempt to coerce the girl by displaying where power lies in the exchange in his inevitable posture of talking down to the child) here opens up the distances between what might be known in prayer and acknowledged in speech, between the desire in prayer and the dissimulation of speech. Telling, then, as it occurs in the adult's request expresses a demand for straight talking, telling it like it is, whereas for the child telling has another paymaster, the truth of the imagination.

But if this were all there were to it, the poem would simply amount to a moral tale in which the cards were firmly stacked in favor of the wise adult, in favor of the social against the individual, but things are more complex than this. In the first place there seems to be dramatized a breakdown of communication, almost as if each voice reflects its words upon itself, so that the child's sense of her words and the value she attaches to them constitutes the sounding board, as it were, which corroborates her belief that the world, or state of things, is anterior to the words used to describe it. For her, experience comes before language, whereas the adult's sense of his

words, of their weight or meaning, is reflected upon the demand he makes that the words he utters refer to what he understands as the consensual "real" world, known to him because known to others. For him language and experience come together. It is important that one sense this in order to recognize what the weight of words is and, therefore, come to understand what it might be to throw words away. In coming to that understanding, it becomes necessary to ask of this reading that it weigh its own words; at the very least an assessment must be made regarding the propriety of these words as a way of interpreting the poem.

This hesitant countercritique is, in fact, already present to the drama of the poem. It can be found in the adult's assessment of the girl's words as weightless, which could as easily be described as his *interpretation* of her words, since it is an acknowledgment of what the girl lacks as knowledge, and an insistence on her mistake or error in belief—that dead or absent people do exist in the same continuum, in the same time and space as those living and present. In this way the repetition of the same words by the girl—"we are seven"—is present as a reminder to the poem itself of its need to acknowledge what it reveals to itself, as if its whole vocation were endless imitation. That is, this repetition serves as a reminder that what is in interpretation—that which is internal to interpretation itself—is not another set of words, a gloss or paraphrase, but another set of reference points for the same words. In one sense, then, the poem dramatizes the impossibility of interpretation, or, to put it another way, it shows how an interpretive act fails to arrive at mutual understanding. Seen from the point of view of the adult, the work of interpretation is understood to equate seeming with being, to correct the world of "as if," of our imaginative lives, so that it corresponds with the "real." But the girl resists this, and in so doing effectively insists on the incommensurability of the everyday world inhabited by the poet and the

world of wonder in which she dwells. For her the repetition compulsion by which the worlds of the living and the dead are sutured into a seamless continuum comes to seem natural: "O, Master! We are seven." It is almost as if the girl, in her repetition of the phrase "we are seven," is enacting the impossibility of interpretation, turning away from meaning (in the adult world) in order to help the words she uses put weight on so that they come to have the force of citations or the ower of spells—citations of how the world is or words of magic and wonder. If her repetitions *are* to be taken as citations, of the world as it is, in what sense do they disclaim or prevent the activity of interpretation? What must pertain if such citations no longer function as, or as a part of, the context of or for interpretation? If the citational is another way of telling, of knowing the facts of how things are, a kind of knowing in between prayer and revelation?

In trying to answer these speculations I would like to begin by noting that neither the reader nor the poet is particularly well placed to judge whether or not the phrase "we are seven" means the same thing to the girl as it does to us (the upholders of adult certainty and sense). The counters we have—the words "we are seven"—must be taken to refer to persons alive; this is their referent. It may well be the case that *this* meaning is indeed starkly, nakedly clear to the girl as well, but it may also be that through the force of her will, or just plain error, she mistakes the nature of the world now after the death of her siblings and continues to describe it with a form of words no longer appropriate to the situation. But this is not how it appears to the poem, which stages an exchange in which the words "we are seven" are up for grabs, are available for differing interpretations— are, in effect, the gift offered by the girl to her uncomprehending and perhaps obtuse inquisitor and, at the same time, the gift of rational certainty returned to her by the adult, an identical form of words that is precisely a different gift but in the same wrapping.

Indeed, part of the drama of the exchange derives from the fact that the possibility presents itself to the adult that the phrase may not be available for interpretation. Consequently, when the girl's repetitions of the phrase are revoiced by the adult—"yet you are seven"—the phrase becomes a demand for clarity itself, and this, in some deep sense, amounts either to a denial of the need for any "interpretation" at all, or, at the very least, to an acknowledgment of the impossibility of interpretation. Of course what is light and fair to one of the protagonists may well be the dead of night to the other. Thus the two worlds, and the expectations encoded in being in those discrete worlds about the necessity for naming and numbering to accord, do not fit together. They ae overlapping but finally incompatible, as if each perceives the other to be odd to its even. Yet part of the pathos of the encounter is produced by the adult's insisting that their distinct worlds fit snugly together, as if this were a matter of getting addition *right*: if two are in the church-yard laid, then ye are only five; as if in telling—both counting and re-counting—the girl would undergo her talking cure. But, as is all too apparent, whenever the poet asks the girl to speak or recount ("pray you tell"), she hears the request to number.

The sense of words or of things here takes on the guise of an echo whereby the adult would be satisfied were the child merely to mimic his words, and this reflects the self-sealed nature of the two discrete worlds. Both protagonists in their different ways open out the distances between echo and citation and, perhaps more tellingly, expose the question of authenticity as it arises in these distances. This is, indeed, a Wordsworthian topos—it can be found in the poem that begins with the voice of Milton usurping the poet's own will to poetry, "A little onward lend thy guiding hand"—in which the prospect of self-citation looms large as the only guarantor of poetic authenticity. The problem with echo, however, is that the voice

returned is not precisely identical to the voice that initiates the rever-
beration. Between echo and citation lies poetry or the poetic voice,
and it is the burden of this distinctively Wordsworthian topos to test
the authenticity of that voice. That in-between allows for a transcrip-
tion of voice, a turning of voice into writing, or an inscription of
voice in the written that might be termed the work of poetry. I take it
that the adult's wish for the proper weight for words is a plea, a poet's
hope and desire, for the proper transcription of voice. But wherein
lies such propriety?

If we follow Wordsworth's lead here the question of propriety
occurs in a particularly telling form for the poet, who both fears and
welcomes the possibility of its being answered. Put simply, how can
one know if it is one's own voice that is transcribed in the troping of
voice into poetry? This is the problem faced by Wordsworth's most
famous projective identification: the Boy of Winander. The question
comes in a slightly different form in *We Are Seven*, where it is trans-
posed into the demand that words retain or regain their weight. This
in turn requires the recognition that what for the child remains indis-
tinguishable in relation to the error of echo is for the adult the hurt
that he must inflict, and that hurt is all the more poignant given that
the adult's motives are, one must assume, all for the good. These
motives are demonstrated by his attempt to resist the seductions of
language, resist being led astray, as if taking on the habit of the girl's
words might lead somewhere one would prefer not to be. But going
astray, of course, is not simply a threat to the adult; it is also one way
of describing the predicament of the girl, who seems to be fully
caught within language's going on holiday. This is both the risk and
the attraction of art. It is for this reason that she is drawn to euphe-
mism in her description of death—first little Jane "went away," to be
followed by John, who was "forced to go"—since the adult demand
for plain speaking ("they are dead") is answered by the girl's rhyming

"away" with "nay," which in the conceptual rhizome of the poem is the equivalent of refusing to make "away" stand in for "dead," precisely rhyming it away.

The poem also stages the transcription of voice that is poetry, lays it out in front of us so that we might count ourselves as implicated within its iteration. I think this is what Wordsworth wanted to achieve in the writing of poetry, and what led to his instruction to the poet in the Preface to *Lyrical Ballads* that he descend from his supposed height and "express himself as other men express themselves." It also suggests that the transcription of these words into poetry, or what might be called the work of figuration, in some strange way neuters the power of the figurative act; at least it sets up the uneasy thought that poetry may be unable to answer the need it speaks and shows. This is equivalent to the demand that poetry reveal or acknowledge its own power; to ask of poetry the source of that power given that the words from which it is made are nothing more than reflections, echoes, transcriptions.

Thinking this way about the poem—directing attention to the sense of avoidance I find articulated by the opening of the exchange (that is, the question of number rather than that of name)—allows me to identify another aspect of my affective response. For what I find mildly perplexing, or at least curious, is the almost deathly lack of friction between the opponents in this encounter. Seen from one angle the poem leaves me cold because there does not seem to be a way of making the two protagonists speak to and hear each other. In another register of my affective experience I also encounter something like disappointment, or stoicism in the face of the inevitable. Perhaps this is akin to the disappointment philosophy encounters when it fails to know what knowledge it might make clear to itself; in the poem this sense of disappointment about what the poem might eventually know is displaced in the adult's recognition that to grow

into adulthood is to forget what it is to be a child, to forget one's founding. It is significant in this regard that the inquisitor opens the poem with a question that cannot be answered; such a question foreshadows the untranslatability of the girl's picture of the world into the adult's. His attempts to get her to speak the "truth," then, are nothing more than transcriptions of the sound of his master's voice, an invitation to the girl to learn the power of imitation and seductions of dissimulation. At the end of the day, however, both the poet and the reader are in poor shape with regard to the question the poem sets itself: What should she know of death? This is why I characterize the exchange as a confrontation between incompatible senses of the fit between knowledge and acknowledgment, or more starkly as an avoidance of acknowledgment, presented to us in the poem as the throwing away of words. Lurking behind this, moreover, I find a darker, stranger sense present to the poem: namely, that poetry is harmful, that it cures what i wants left uncured—for me, at least, this sense is present in the hesitation of the poem's conclusion.

That hesitation appears when the demand for clarification— "How many are you then?"—is once more avoided, resisted, or refused; and once more the girl's return of her voice, her voicing of number, seems to tell a story the poet cannot know, cannot hear. It is as if he hears in the repetition of the words "we are seven" the hurt he sets out to help. There is, therefore, an intense and pathos-driven irony in the inquisitor's call for clarification; something like this intense irony is present in Wittgenstein's repeated call for clarification so that philosophy might cure itself of the disease of which it is the cause. That this irony is heard, at any rate, bears witness to a certain distance that can be said to figure the poem's own sense of bewilderment or wonder in the face of a question that it knows it cannot answer, fears it cannot speak. It is also a mark of having heard or noted the barely audible sound of a hurt in language, revealed by

this poem in the course of its work, of its writing, and it is the cause of this that becomes the full burden of the poem to discover and to heal. The pathos I referred to above derives from the fact that the poem is itself the cause of the hurt it seeks to uncover and to heal. In this regard it is surely noteworthy that the project of the *Lyrical Ballads* (albeit retrospectively named in the Preface appended to the second edition) explicitly sets out to adopt the "language really spoken by men"; that words might be brought back to their everyday uses is, of course, as much a Wordsworthian project as it is a Wittgensteinian one.

Thus far I have pressed hard on the exchange between the protagonists and have highlighted certain aspects of their conversation. But in remaining fairly close to the material of that exchange perhaps I have committed an impropriety—as if this reader *overhears* the exchange, in the struggle to listen in on a private conversation. Perhaps all poetry courts the same possibility—is inevitably attracted toward the shadows that fall between public speech and private prayer—so that we always sense ourselves at the edge of a conversation or in the margin of some form of textual process. Perhaps any and every reading by necessity courts the impropriety of listening without invitation, hearing without acknowledgment. Whether or not this is a generalized feature of all encounters with poetry, it is close to the material conditions of production for this particular poem, and it sets up the uneasy habit of echo or drift toward ventriloquism that characterizes my reading of the poem.

Those material conditions can be brought to light by recalling the story surrounding the composition of the verses. Wordsworth and his habitual companions, his sister Dorothy and Coleridge, were sitting around one day when Wordsworth, who had just completed the poem, asked the others to produce an opening stanza. Wordsworth writes in his Fenwick note:

When it was all but finished, I came in and recited it to Mr Coleridge and my Sister, and said, "A prefatory stanza must be added, and I should sit down to our little tea-meal with greater pleasure if my task were finished." I mentioned in substance what I wished to be expressed, and Coleridge immediately threw off the stanza thus:

> A little child, dear brother Jem,

— I objected to the rhyme, "dear brother Jem," as being ludicrous, but we all enjoyed the joke of hitching-in our friend, James Tobin's name, who was familiarly called Jem . . .[2]

What concerns me here is not that the first stanza was written last, but that the poem opens with the gesture toward another person, an interlocutor who frames, or generates the context for, the narrative encounter. The poet seems to feel the need to pen one final, opening, stanza for the poem. Although this cannot have been prompted by formal considerations, it nevertheless opens up the perplexing question, When is a poem complete? How can one tell that one's task is finished in the business of making art? Does this anecdote point to the fact that Wordsworth did not, himself, complete the poem at all? That Coleridge did that work for him? What are the issues of propriety here? Now what ought one respect as one gets closer to the compositional environment in which the other members of the Wordsworth circle were clearly participants in the creative process? In relation to these questions it is important to call to mind that Wordsworth deliberately constructed a kind of echo chamber, a hall of mirror-like citationality, in which the entire drama of the poem is to be played out. Furthermore, we should remember that the immediate context of performance and composition engaged his intimate circle, who expressed their gratitude by

"enjoying a joke." There is, at least to my ears, a kind of awkwardness or discomfort in this response: the laughter—if indeed laughter there was—stands in for or covers over something more keenly felt.

The poem itself inquires into the source of such an affective response—discomfort—and this inquiry is intimately connected to the Wordsworthian commitment to a commonplace sense of the worth of words, to the curing of the ground of poetry. It is the distinctiveness of this project that requires what I earlier described as a particular sensitivity to the Wordsworthian-ness of the text. In the poem at hand I think that such sensitivity helps articulate a question that is not so much raised *in* or *by* the poem but lies adjacent to it, within the response I am mapping. This question concerns the knowing that is the artwork, the knowing that is this affective response: What does the text know of death? Although I take this question to be outside the poem itself, there is, nevertheless, help to be found within it, and that aid comes in the form of a recognition; namely, that the child means something by the statement "we are seven" that is not meant by the poem itself, or at least is unavailable to the transcription of voice that is the poem. Hence my question: What does the text know of this, what does it know that the reader (as yet) does not, perhaps cannot? As this book has attempted to demonstrate, this is a question not only for *this* poem, but for artwork in general.

From the evidence of the poem it is quite clear that whatever the girl means by this statement—is it an avowal of a state of being, being seven, or an indication of numeracy, being able to count?—it is not the same as what the poet or inquisitor means by it; as noted, the drama of the poem stems from its opening and enlarging upon this area of broken language. Whereas the poet may be seen as attempting to give to the child a properly adult sense of language's relation to event, to person, to being, the child, for her part, is remarkably unperturbed by the corrective literalness of the poet/inquisitor.

Whereas the child speaks with one tongue, meaning one thing that is merely rehearsed over and over through repetition, the poet hears many tongues, hears his own meaning but recognizes the potentiality of other meanings in the words given to him by the child. He, in turn, recites these words back to the child, returning the gift in and through his own voice in order to cure what he takes to be the derangement of the child's voice—"yet you are seven." But does the child also recognize that difference? If she does, must her refusal of the adult description of her dead siblings be taken as a resistance to what he, and we, know of death? If so, the initial question posed by the poet—"how many may you be"—takes on a darker, more coercive sense since there is more at stake here than a question of number.

In reflecting on this I begin to wonder how one might oneself reply to such a question, and how one might avoid asking it of oneself. Perhaps this is the source of the disquiet I feel in relation to the poet/inquisitor's motives, even as I recognize the inevitability of his concern with number. It cannot, however, be taken as "natural" that he should ask the question of number first—surely the common experience of this kind of situation would more readily yield up a question of naming—What's your name, little girl?—and, reflected in this light, the insistence of numbers in the poem begins to take on a weight that words themselves, names perhaps, do not have. Naming, for the child, is an extension of the presence she feels all around; to name something brings it into the region of being, dwelling. But numbering also performs this function for her. Numbering, as a conceptual operation, requires the ability to count up not only things present but also those absent, so to some extent her ability to count correctly is recognizable to the adult. But for him the naming and numbering of dead people in the same fashion as those alive constitutes a lesion in language's power of presentation. Naming and

numbering, in their distinct ways, say something about one's habitus, how one feels oneself to be placed in the world. To name things is not to interpret them, but, as Wittgenstein says, a preparation for saying something. It is, however, the site of contest in the poem that the facts of number are interpreted correctly, and that these facts remain distinct from but accord with acts of naming, that is, observe their propriety. The issue here is not whether or not the girl can count, but whether she can name all she counts — is her counting a prelude to naming or its substitute, an act of acknowledgment or interpretation?

This difference between naming and numbering — difference of attitude to those conceptual operations — provides the poem with its energy, or will to be, and hence contributes to what I take to be the compelling force of the poem as a work of art. Furthermore, that we will never know the name of the little girl both contributes to the affective pathos of the encounter for the poet and instills a sense of mystery or of unfinished business in any reading of the poem. Wordsworth was himself aware of this mournful harmonic in the poem, writing in his Fenwick note:

> . . . in the spring of 1841 I revisited Goodrich Castle, not having seen that part of the Wye since I met the little Girl there in 1793. It would have given me great pleasure to have found in the neighbouring hamlet traces of one who had interested me so much; but that was impossible, as, unfortunately, I did not even know her name.[3]

Perhaps it is beside the point, or improper, to note that the poet would have encountered the same difficulty with the girl's siblings, both of whom are named, for they, of course, are dead. A shadow on that impropriety is made visible in the observation that both dead siblings had names beginning with the letter "J" — something they share with the rejected name "Jem." At the time of the 1793 walking

tour and the subsequent writing of the poem, Wordsworth's own brother John was still alive; by 1841 he had been dead thirty-six years. The matter of the poem *We Are Seven* can hardly be termed proleptic with regard to John Wordsworth's death at sea in 1805, for how could the poet have foreseen such an event in 1793? Even so, the spectral imprint of a death foretold hovers above the poem like a countervoice murmuring, "List, O List!" Nevertheless, the propriety of this question—or the propriety of demanding an answer to it— somehow seems questionable, perhaps because its answer remains unknowable, and not only to me, the reader.

We Are Seven is, however, manifestly about our attitudes to death and the dead; it asks of itself this question of propriety. It poses the simplest and most naked of questions we all face when someone— usually not well known to us, even a stranger—tells us she has lost a friend, relative, sibling, parent, or loved one. What form of words is, on such occasions, not only appropriate but, more important, intelligible to the interlocutor whose loss we first try to recognize and understand and then ameliorate or, through empathy, even share? It seems to me that this is what is at stake, or at issue in the poem *We Are Seven*; this is what I will characterize as the knowledge the poem strives to acknowledge but not to interpret. I do not mean this in any trivial sense at all; I do not mean to note that the poem is, at some level, about bringing back, as to life, something that has gone or something one has lost. Nor do I mean to trivialize the poem's attempt to deal with that loss, with what one feels at another's death. On the contrary, it seems, in the light of these remarks, incumbent upon me to go beyond these observations in order to allow my *aesthetic* response to formulate its own question, or, to put it another way, to allow that question to be formulated and heard. Hence my return to the inquiry that prompted these speculations: "What does the text know?"

It is important to recognize that this question, even now, is only barely intelligible, and that the only place in which it might gain some clarity is within an *aesthetic* experience. Since that affective response is equivalent to the material of the artwork, it is legitimate to characterize the poem as phrasing this question to itself, as asking itself about the knowledge it strives to acknowledge. I wish to stress that this is not to be taken as the "meaning" of the poem; indeed, it is not in any proper sense a question for the poem or a property of it since the question only appears within my affective response. It is one way of giving a name or a face to my *aesthetic* experience. A Wordsworthian image comes to mind here: the sense of clearing I feel in the process of my affective response is rather like the opening in the clouds that reveals the repetition of the stars on the surface of Grasmere Lake in the poem "Composed by the Side of Grasmere Lake." In a different vocabulary the question of knowing, or of acknowledging knowledge, comes down to the issue of sense, of making or recognizing sense. One might phrase the question thus, How can one *make* sense of the world, how can one make *sense?* The fact that put this way the question appears so obvious does not, at least for me, diminish its power or poignancy. Nor does the conspicuousness of the word "sense" diminish its importance for the Wordsworthian project. Indeed, part of the pathos of the encounter dramatized in the poem *We Are Seven* derives from the particular pressure brought to bear upon the sense of sense by that project. Does the child *make* sense, that is, construct for and from within herself the meanings she lives by, inhabits? And if she does, can I—that is, the reader of the poem—make sense of (in the sense of understand) that? The fact that sense—sense-making, understanding, feeling, interpreting, sensing, being sensate—itself creates the confusin of sense (meaning) is, of course, a Wordsworthian topos (brilliantly explored by William Empson in *The Structure of Complex Words*)

and can hardly be claimed as an original insight. Nevertheless, its presence here in the poem prompts the form of my affective response, that is, its citational or ventriloquial manner. Here I mean to point out the *citational* status of these words of elaboration; they occupy a place or zone somewhere between a reading and a gloss—almost as if they themselves constitute an itinerary, as if they are on the way somewhere. And I would characterize that itinerary as the recognition that one may never know the knowledge that is known to this poem, but in acknowledging that one might, at the end of the day, come to a sense of what that means *for oneself.*

Where one ends up, then, remains indistinct (certainly to others) yet tangibly immediate (for oneself). It is a place, a dwelling—perhaps another vocabulary should intervene here: dwelling, building, thinking—in which I am both uncertain of what I know and, at the same time, unperturbed by that uncertainty, at home in it. Equanimity lies at the heart of this experience; or, to put it more accurately, equanimity is the name and face I give to the living through of this *aesthetic* encounter: what I sense, and sense as a way of knowing, is a kind of quiet resignation or stoic acceptance of the limits of knowledge.

Wordsworth had other terms or near terms for this: tranquility, for example, or the famous phrase from the poem commonly known as *Tintern Abbey:* "a sense more deeply interfused." This, I take it, is like the thoughts that lie too deep for tears, that which is internal to poetry, to poetry's sense of itself in the Wordsworthian idiom, to what Wordsworth called "truth." And it is poetry's fate—the fate of art—to continue probing that interior. Poetry for Wordsworth suffers from a malaise, or entertains a prospective desire, namely, its inability to give up—in both senses—its truth. This is why the word "sense" has such a productive role to play in the Wordsworthian poetic topography, for if a word more precise or lacking its own peculiar weight

were substituted then it would signal the fact that we or poetry has ended, that we may end, that we or poetry is at an end. This would be tantamount to the acceptance that poetry has yet to begin. Wordsworth cannot face such a state of affairs, and his little cottage girl, like the solitary highland lass of the *Solitary Reaper*, like so many of Wordsworth's projective identifications, is there to remind and rebuke him for entertaining the notion that poetry might come to an and, that one might be able to answer—if not in full at least to our temporary satisfaction—the question, "What does the poem know?"

It is clear, I think, that the drama of the poem *We Are Seven* is constructed around the question of ending, coming to rest. Perhaps it needs to figure out for itself as much as for us what it would mean to come to an end. What it might be to bring explanation, here figured as the desire of the adult, his gift to the child, to its rest; that is, acknowledge that words come to their resting place in explanation, as they would if the child were to accept the inquisitor's meaning of the words "we are seven," in other words, to accept the gift of adult sense. The figure of the stubborn interlocutor is there to remind the poet that if words—as a prelude to being—were to come to rest in explanation, then a certain loss or sorrow would result since such a resting point or ending would signal the foreclosure of sense, or of sensing. This is why the adult's sense of ending, of ending as sense, is anathema to the poet, who could not find it within himself to publish his greatest work, *The Prelude*. Poetry, for Wordsworth, must continually ask itself the question of its own knowing, constantly probe the truth it knows yet struggles to reveal. This process cannot end, be in the house of adult certainty; that this is so is one of the axioms of a distinctively Wordsworthian concept of writing, and finally of being: precisely the admonishment from art that we learn the acceptance of solitude, learn to be at one in that knowledge, face it with equanim-

ity. This is why the notion that some thoughts lie too deep for tears is one of the lessons that should be taken away from any encounter with Wordsworth's poetry.

In conclusion I would like to return to the question that has preoccupied my discussion. I have been suggesting that, among other things, the poem *We Are Seven* dramatizes two opposing views about the relationship of language to experience, of the word to the world, and that it sets itself the task of inquiring into the authenticity of an experience for which the words used—"we are seven"—no longer correspond to the facts, to the world as it is, and as it is named by those words. This inquiry, which at base is an investigation into the relationship of art to the world, its knowingness, leads to the possible conclusion that poetic voice may be "inauthentic," that is, it may reveal what *we* cannot know as knowledge. This is figured by Wordsworth as a hurt in language, as something that wounds when it sets out to heal. I have given a name to that hurt: it is the iterative plea on the part of the poet/inquisitor that *We Are Seven* and "we are seven" bear witness to the fit between naming and numbering. Following from this, it is this hurt—allied to the hurt in language that is death for this poem, as it is for the group of poems known as the Lucy poems—that is exposed or revealed as the fount or origin of poetry for Wordsworth. Hence a dilemma arises: if the origin of poetry is "inauthentic" in the sense of untrue to experience, how might the poet cure this, trope the voice one more time so that it cures the ground upon which it stands? This is why the voice is such a profound topos in Wordsworth's writing—it both produces the art that is poetry and, at the same time, is the means by which the authenticity of that poetry is tested, ascertained, brought to judgment. There is a cost as well as a potential gain involved in this that can be illustrated very easily by the poem *We Are Seven*. The cost of refusing the adult's certainty is the relinquishment of judgment; the prize of retaining

the girl's aswer is the unknowable authenticity of poetic knowing. Thus it was Wordsworth's strange genius to ask what experience *of the world* might be if not an experience of poetry's troping of the world. And for him this led to the fear that if experience of the world is not figured in or as poetry, then to be worldly, in the world, is to be outside the gift of poetry, to be, in some measure, too human for comfort.

5

Fragility: The Architecture of Wonder

I THINK OF THE THREE PRECEDING chapters as fragments from an *aesthetic* education. They provide snapshots that, when combined, begin to constitute a map of my affective experience. But for reasons I will address below, the coherence or intelligibility of such a map is hampered by a number of features common to each response. First, all three accounts inevitably appear to be complete or finished—as if in writing about my experiences I have brought them to a close or cast them in something like their final form. Second, in committing these experiences to print I may have given the impression that they came easily or were instantaneously recognizable to me as precisely *aesthetic* encounters. Perhaps it is again inevitable that the work required to see them this way will, to some extent, be erased in the act of telling. Moreover, the effects of these experiences—the disturbances they cause as well as the pleasures they have occasioned—lie somewhere in the background of my discussion, for the unavoidable consequence of

attempting to get my descriptions *right* is to introduce a certain distance between the experiences, their effects, and these printed observations. It seems only correct to state, however, that the attempt to make the mute articulate has been a much more varied and at times arduous task than the smooth flow of these chapters might suggest. The responses I have presented can only be interim reports in an ongoing process that is as likely to stall, once again, as it is to exfoliate further. This is all to note that my accounts seem to me to have been hard won.

Having come this far, however, I can now ask what might improve my understanding of these experiences, help me be more at home with them, learn how to use them better. It is, of course, tempting to imagine that this need could be filled by some form of theoretical or conceptual elaboration—precisely a theory that might be drawn out of the exemplarity of my presentations. If this is so I have been unable to find a glove that will fit because the particular difficulties of elaborating on these *aesthetic* encounters are tied up with their *radical* singularity. Consequently, what is required is some form of further elaboration—call it theoretical articulation—from *within* these experiences. It seems to me that this will almost certainly necessitate thinking the conceptual or theoretical differently. Or, at the very least, that what we do with these cases of radically singular experience, how we use them, deploy them, learn from them requires a different set of protocols for thinking about or articulating the conceptual basis of art or *aesthetic* experience. Making sense here might well be more like the making that is art than we yet fully realize. The working term I have for that sense-making is the practice of wonder.

I have said that I recognize the temptation to provide an overview of the three examples as if in doing so common threads might emerge that could then be woven into some kind of general position

vis-à-vis the artwork or the concept of the *aesthetic*. I think it is pretty clear that I have taken common themes or approaches to the works: the question of address and the preparation necessary for an *aesthetic* encounter is one such theme. The quality of distance is another. My encounters have, for example, circled around the idea that artworks state their presence to us in ways that might, at least at first, be strange or disquieting; time has also featured in my discussion of more than one work and is another preoccupation. But these themes or issues could never have universal status for two very good reasons: in the first place they are features of my responses; they are my pre-occupations and not someone else's. In the second, these common threads are merely ways of opening out my responses to the works at hand, ways that seem to work for me. They are features of my own aesthetic attitude, lenses that enable me to see better the artworks concerned. However, and here is the sting in the tail of the radical singularity of *aesthetic* experience, these themes and approaches appear to me as attributes of the works themselves. In other words, they tell me something not only about how I tend to approach these specific works but also about those qualities I perceive to be internal to them. Given the latter perception, I believe these qualities to be perceptible to others as well.

Although these common themes or approaches may appear to bind my three examples together, I did not choose these works because of this. In a sense, of course, they chose me. They are works I love, works that have returned my interested gaze repeatedly, works that are not yet done with me. In setting out to inquire into the sense of being profoundly moved by a work of art it is hardly surprising that I should have selected three artworks that, more intensely and more reliably than other works, set in motion the particular sensation of the affective I have been at pains to describe. But in selecting these and not others I have also been keenly aware that something is

exposed, made visible, public. So this is work you love. And I am, of course, only too sensitive to the fact that as much is said about me in my selections and descriptions as about the works themselves. Perhaps this accounts for what I described in the Introduction as a general reluctance to confront the mutism of our aesthetic experiences: we resist making our private inner lives too public.

The history of inquiry into the aesthetic could be productively placed in parallel with the history of the development of modern conceptions of subjectivity. In an earlier book I traced one strand of that parallel history; this book, however, has only glancingly gestured toward this approach to the topic. But I think much could be said about the demise of a particular interest in the aesthetic and the rise of psychology; in some yet to be fully examined way theories of subjectivity that developed in tandem with and within psychoanalysis attenuated the need for a fuller investigation into what was posited in psychoanalysis's prehistory as the therapeutic force of art. While art or the aesthetic is sometimes said to have filled the vacuum left by God in the rationalizations of the Enlightenment, psychoanalysis could be said to have replaced the inquiry into the claims for transcendence made in the name of art. If this is so, my desire to make the mute audible could be taken to signal a return to a countervoice that might be heard alongside Freud's talking cure.

It is also inevitable that something will be read into the fact that all three of the artworks I have chosen here are examples of "high" art, accredited art. It is equally certain that some readers will see this selection as grounded in a number of politically unpalatable claims—concerning competence, education, training, taste, or expertise. But I have resisted the equally unpalatable move to include works merely in order to be politically correct, or to appear fashionable. In setting out to explore the material of affective experience, of *aesthetic* responses to artworks, I obviously needed some evidence,

something I could identify as this kind of experience, something that would persist or be sufficiently robust to withstand close scrutiny. What seems to count here is the strength or depth of the *aesthetic* response. Given my initial premise concerning the "mutism" that frequently accompanies our affective encounters with art, these powerful instances would, most likely, prove to be the most intransigent with respect to my attempts to find a way of making the mute audible. They represent, then, as good a test case as I could muster. But it should also be made plain that these are works about which I am prepared to risk having a say. And I am prepared to take that risk because they are works I care about.

It seems to me that more could be said about this, about caring for a work of art and what that might entail, and, furthermore, why these are some of the works I care about. But as should be clear by now, my project is not in a simple sense an autobiographical or personal one, even though elements of autobiography inevitably intrude. I have deliberately put such considerations to one side because they are distracting to my purpose: they allow me to answer too easily the awkward questions I have posed, as if the singularity of *aesthetic* experience has its only explanation in my proclivities, desires, appetites, formation, as if these experiences were subjective in the weaker sense. In contrast to this my wager has been to assert that they may be more than this, not only this, something else perhaps stranger and more difficult to access but nevertheless worth the effort of serious investigation.

For the same reason I have deliberately put to one side non-aesthetic considerations of these works. Indeed, I have set out to treat each work on its own, attempted to allow the work itself to guide me in the exploration of my response. For similar reasons I have substantially neglected consideration of the interrelations (where they exist) among the three works or my responses to them. All of these decisions

are *strategic*; they have been taken in order to get a firm grip on what I have narrowly defined as the *aesthetic* aspect of a work of art and a response to it. All works of art are embedded in contexts, just as our responses to them come attached to who we are, where we come from, what we wish to take away from an encounter, and so forth. But, as the critic Clement Greenberg observed, there is a heck of a difference between an *aesthetic* and a non-aesthetic context. I have tried to keep firmly to the former while recognizing that at some point the latter will inevitably intrude. And the only way a work's *aesthetic context* may be identified or located is through an affective encounter with it.

My working method has been to question the status of my responses, to inquire into their doing, their making, to preserve or enhance their differences from other kinds of experience in order to examine those differences more carefully. This has led me to conceptualize hypothetically these experiences as having a cognitive component—deliberately resisting the absolute divide between affect and knowledge—in order to test the hypothesis. This is why I have asked if my responses give me knowledge, and if so, knowledge of what? My answer to these questions has so far embraced the notion that such knowledge is an illusion or virtual effect of an *aesthetic* encounter since it clearly does not conform to the working definitions of either propositional knowledge or knowledge by acquaintance. This leads me to ask if the fault here lies in a too restrictive understanding of the category "knowledge." What might be required, then, is a radically different conception of knowledge itself. This kind of knowledge would not be exclusively the property of an agent, not something I own or could be said to be familiar with. It would also be within the artwork, something, as it were, known to it. Although it makes no sense to talk of this as propositional knowledge, it is equally unsatisfactory to dismiss out of hand the sense of

knowing that is made apparent to me in an *aesthetic* encounter. I prefer to call this a knowing rather than knowledge since it is more like a state of mind than an item of knowledge. And I call that state "wonder."

The literature on aesthetics does contain accounts of the cognitive dimensions of art and aesthetic experience. It is quite frequently pointed out, for example, that artworks have cognitive as well as aesthetic and ethical features. But I do not mean to address this aspect of a work's cognitive claims, the kind of thing whereby we note that a novel may present cognitive truths about a place or a thing, or ethical truths about human motivation, and so forth. It is also relatively common to find accounts of the cognitive component of aesthetic perception itself. Here the peculiar quality of aesthetic perception is said to lie in its ability to enable cognition of so-called aesthetic properties of the work. But this form of inquiry is also adjacent to my concerns. The growing body of recent work on emotion and its relations to cognition is closer in orientation to my work here, but even so the fit is far from close given that the experiences I have described are not in any simple sense emotive. I have spoken about feeling or sensing something as a way of identifying an *aesthetic* experience. But I have also taken pains to point out that the vocabulary I have been exploring—serenity, clarity, and so forth—is intended to name not a feeling or emotion in me but a quality in the work (although, as I have said, this feeling may be present to the affective response). Or, more precisely, it is intended to name a virtual quality of the work residing in the space between the object and my appreciation of it. As noted, we only *sense* it to be in the work—this is its distinctively *aesthetic* character—since it is clearly within us. What I am trying to direct attention to is a peculiar feature of the artwork, its "art-ness" rather than a feature of my response. The difficulty here is that such a feature of the work is only visible to me in my response.

Another way of seeing this is to return to the question I raised in my introductory chapter: "What is an *aesthetic* experience *of?*" Throughout the previous three chapters my attempts at answering this question have taken the form of identifying different moods of knowing—serenity, equanimity, and so on. Such moods are partly a quality of my response—in that sense they are like feelings or emotions—and partly a property of the artwork. It is important to recognize that affective experiences as I understand them are not equivalent to undergoing or being subjected to a feeling: the artwork is not a prompt enabling one to feel sad, joyful, serene, or anything else. Even though we may use artworks in this way—tonight I listen to Beethoven's third piano concerto in order to feel something familiar (say, elation)—when we do so we are not responding to them *aesthetically*, at least insofar as I have been using the term. As I stated in the Introduction, while the feeling may well be a good place to start in the examination of an affective encounter, it is merely an aid in getting toward the material of an *aesthetic* experience.

There is, then, a certain distance for me between emotion as it arises in the practice of everyday life and affective experience as I have been using the term. This distinction can be illustrated by noting the difference between feelings aroused by artworks and those occasioned by our coming into contact with natural objects. Although the literature on the aesthetic, from Burke to the present day, often conflates our experiences of these two things, I understand them as distinct. The crucial difference between the two lies in the fact that an *aesthetic* experience as I understand it can only be of an artwork because it leads me to intuit that something lies within the work that was placed there intentionally. And that something is, as it were, known to the work, and it is what I have to figure out. Mountains do not result from intentional activity, so even if I notice a similarity in my response to a mountain and a text, I do not then imagine

the mountain to contain within it something I have to work out: the experience is decidedly in me; it is my reaction to an encounter with an object in the world. The problem with *aesthetic* responses is that they are like this but not entirely. They also feel like something else. This returns me to the radical singularity of *aesthetic* experience. In the case of the mountain it is easy to see how responses to natural forms are constructed through social practice, and this leads to the establishment of norms of response. We know we are *supposed* to react in certain ways and duly conform (or not, as the case may be). Although the experience of artworks also takes place within ritual-ized social conventions and these may be decisive in how we experi-ence the work—and if they are decisive the resulting experience may well be identical to our reactions to natural forms—they are not always. Or not exclusively. As Kant remarked, *aesthetic* experiences are based in the subjective *a priori*; they are radically singular.

The singularity results from the subjective nature of such experi-ences, which are radical because they give rise to judgments that appear to the perceiver as both universal and necessary. The experi-ence is unique to me but gloved in my sense of being a member of a community that *must* feel the same way as I do. This is certainly one of the things known to *aesthetic* experience, so to some extent one might call this the distinct "knowledge" that artworks give us. But they do more than this. Each experience is singular not only to each viewer but also to each work. An *aesthetic* experience is made out of its own singularity. This is why I do not have *one aesthetic* experience that is merely repeated again and again each time I encounter a dif-ferent artwork. The response is determined by the distinctiveness of the "art" component of the object. This observation is intended to ward off the confusion that arises when different aspects of the art-work—the physical material from which it is made, social or politi-cal articulations, and so on—are conflated with its "art-ness." If I take

a chair, for example, and place it in an art context—in a museum, say—the "art" lies in the activity of placing the object in such a context. That is the making of such a work. If I then place a vacuum cleaner in the same context, I have to all intents and purposes made "the same" work. Here my *aesthetic* response, which, recall, is a response to the art component, *will* be identical or very nearly so even though my non-aesthetic response will most likely take on board the differences between chairs and vacuum cleaners—their different functions, social meanings, relations to the skills utilized in their production, and so forth. What I mean to call attention to, then, is the distinctiveness of our *aesthetic* responses, and these certainly *are* dependent upon the differences in "art-ness" weencounter through the materiality of an affective response.

I now would like to turn to the form in which my encounters have been presented. In a clear and obvious way my discussion of the three works proceeds by way of description, although what is being described will require further comment below. The language of description may aspire to something like a "pure" form that colors or clothes its objects neutrally. Such a value-neutral descriptive language is, of course, only ever at best an aspiration: even the starkest descriptive statement encodes evaluative criteria. Thus, to make this concrete, my attempts at describing the affective encounter with Gould's *Goldberg* come wrapped up in a set of implied evaluative stances and observations. But even if a neutral language of description were possible, even if my account of clarity, say, persuaded another listener that this quality was present in Gould's rendition of Bach's music, it still would not necessarily lead such a listener to undergo an identical affective experience. In other words, although I can show others aspects of the work they might miss just as they are able to reveal to me what I overlook, the best I can do is *hope* that by showing these qualities others will be able to perceive what is within

my affective response. But, and this is the rub, by showing such traits I cannot *compel* a similar response nor a similar value judgment. For some writers on aesthetics this points up the error of taking descriptive statements as if they were without motivation. According to this way of seeing things any descriptive statement is functionally dependent upon a prior evaluation, and, furthermore, the evaluation cannot be reduced to a justifying description since it is possible to agree with the description as a just and accurate statement without at the same time arriving at an identical evaluation.

This problem stems from the ambiguous nature of the term "judgment" in the Kantian analysis of the aesthetic. On the one hand it contains the sense of discrimination, while on the other it refers to one of the ways in which we understand things via our apprehension of rules. This is what Kant calls "subsumption"; judgment is "the faculty of subsuming under rules." Thus when people talk of "aesthetic judgment" it is often unclear if both of these senses are to be operative. A further problem ensues from Kant's claim about the non-conceptual basis of aesthetic judgment. This may hold in the second sense of the term, but it is hard to see how judgments in the sense of discriminations could be made if they were not grounded in one prior concept or another. Once again the paradox of the *aesthetic* raises its head. The *aesthetic* is both grounded and not grounded in the conceptual, both singular and universal, evaluative and descriptive. But I do not regard these difficulties and paradoxes as anything other than attempts to delimit the distinctiveness of the category of the *aesthetic*. It is precisely these paradoxes and difficulties that need further exploration and elaboration.

Thus, while I recognize the singularity of the affective encounter and know that it is subjective in the sense of being unique to me, I also come to a judgment about the experience (and hence the work) in the discriminatory sense. And this judgment feels *right* to me; it

feels as if another viewer, reader, or listener should also be able to see what I see in the work and therefore come to a similar evaluation. This is, as it were, the grammar of the concept "*aesthetic* judgment." The consequence of this is a sense that the matter or material of the experience is held not within me but within the work and that it must be, accordingly, available to others. This is also why I am capable of having different *aesthetic* experiences, and why I continue to seek out, encourage, or enhance moments of wonder by encountering new and different works of art—or re-encountering works I have forgotten or mislaid, or even works with which I am very familiar but approach in new and different ways.

It seems to me that practice benefits *aesthetic* experience. I may not necessarily get better at understanding *aesthetic* experiences, but I can increase the chances of having them. Most important, I can begin to recognize more easily what such experiences feel like or do to me. Having said this, however, I know that each and every artwork I encounter asks of me the same question: How can I prepare for the acceptance of *this* art; How can I make myself ready to accept *this* work? Here one returns to the radical singularity of *aesthetic* experience; this is why practice, seen from this perspective, does not make perfect. Each time I confront a work of art I must begin to negotiate the risks attached to a process of opening myself to a text, painting, or piece of music; I must steel myself for the uncertainties that lay ahead if I am to become intimate with the work's way of knowing. And in a simple sense no amount of practice or training will help me here. Yet, and once again the paradoxical nature of the conceptual formation of the *aesthetic* makes itself felt, over time and with repeated exposure to works of art I become more familiar (though not necessarily more comfortable) with taking the risks required. One such risk is the possibility of being changed through an *aesthetic* experience—an outcome that may engender considerable

anxiety. Perhaps this accounts for the low frequency—at least to me—of profound *aesthetic* experiences.

The profoundest *aesthetic* experiences alter our perceptions of the world, sometimes in very small ways, sometimes in much larger ways. They may raise in us a number of different sensations—joy, fear, terror—that come attached to the *aesthetic* but should not be confused with the distinct and uncanny pleasures of being lost in wonder. Before returning to Marc Quinn's *Self*, I would like to explore briefly the nature of that pleasure.

THE STATE OF WONDER is more hospitable than awe, which has the capacity to trouble or disturb us, and it is less engrossing than rapture, which seems to swallow up all sense of self. Wonder has a residue of comfort or safety, a bolt-hole for when things get too far away from the possibility of understanding. It is distinct from surprise, which may nevertheless often accompany a sense of wonder, act as a prompt or prelude to it. The big difference here is that I can remain *in* wonder, be in it, whereas the structural formation of surprise requires that the feeling die away almost as soon as it comes upon me. Wonder has an identifiable architecture; it comprises a variety of rooms we inhabit, moving from fascination and curiosity through admiration toward, at the lowest levels below ground, as it were, stupor or stupefaction. That is when wonder runs out, when all the energy of the spell-binding has been exhausted.

Surprise is a frequent component of my affective responses to art, but if my experience of the work stays with this response I quickly lose interest: surprise often fails to be converted into something more compelling, like wonder. This is why artworks that shock, whether or not their authors consciously set out to provoke such a reaction, provide us with weak *aesthetic* experiences: we are brought up short,

confronted with something new and for which we are unprepared, but sooner or later (and very often simply sooner) we find it very easy to accommodate the new and to render the force of the shock unremarkable. Furthermore, by and large the more shocking something is initially the faster and more facile the accommodation becomes. Wordsworth had a good phrase for that which takes a little longer; he called it the "shock of mild surprise," and the milder the surprise, generally speaking, the more enduring the shock. Artworks that court this sensation are generally less compelling or interesting to me than those that may begin by surprising me but end up leading me into something else, say, amazement. Much contemporary visual art has the capacity to shock in spades: many of the works in the Saatchi Collection displayed at the 1998 Royal Academy *Sensation* show would provide good examples—the sculptures produced by the Chapman brothers that distort the human body and displace the sexual organs come to mind—of how surprise quickly runs out of steam, loses its appeal, fades into the familiarity of being shocked. The interest of this show was severely diminished for me by the frequency of this structure of response in the face of many of the works displayed.

Adam Smith noted that surprise may lead to wonder if we find ourselves unable to reconcile the new with the familiar, but once again the milder the surprise the greater the propensity for difficulty in reconciliation. Wonder is an aesthetic state, it engrosses the mind only to lead it to a kind of distraction. Being in breathless wonder is a form of inattention. When I find myself in wonder I try to remain there, poised in this state, deliberately holding off the onset of expectation or the moment of release. I feel absorbed but unable to touch the source of that absorption, keenly aware, in a heightened state of perception yet at the same time lacking focus. It is almost as if my self lacks consistency, or precision. Being in wonder is a kind of con-

templation without object, a suspension in attentive inattention; I am at the same time both completely absorbed and distracted. Such dumbfounderment may cause a sense of inadequacy in the face of the object that prompted the wonder, as if I am forced to recognize the limits of my perceptual powers. But this feeling is also often replaced by an intensification of self-presence. The state of wonder, then, may be both compelling and disabling at the same time: it leaves me wanting more but also slightly relieved when the moment has passed. I am certain that our fascination with great works of art derives from this push-me-pull-me state of knowing. We both want or seek out the mysterious powers of *aesthetic* contemplation and at the same time feel slightly apprehensive about what might be revealed in the moment of wonder. Or, to put it another way, we are certain that with time and effort (or sometimes just plain luck) we will be able to penetrate to the core of our cherished works of art but know that they are cherished to the extent that they will never, completely, give up what it is they know.

What makes *aesthetic* experience distinct from other forms of experience is its absolute divorce from the ordinary or everyday. Yet, in a strange way, the inattentiveness of the habitual is a correlate of affective experience; wonder is, as I have said, a kind of distraction. It also feels as if it comes, as it were, before knowledge, since, as Socrates remarked, the primary motivation of wonder is the recognition of ignorance. Wonder requires us to acknowledge what we do not know or may never know, to acknowledge the limits of knowledge. It is, then, a different species of knowledge, a way of knowing that does not lead to certainties or truths about the world or the way things are. It is a state of mind, of being with the world and oneself that, like being in love, colors all that we know we know. And that can, on occasion, certainly appear to be like thaumatology: the science, or knowing, of wonders and miracles.

IN CONCLUSION I would like to return to the work that opened this book, a sculpture that was also shown in the *Sensation* show: Marc Quinn's *Self*. As noted, no other work moves me more than this compellingly beautiful cast made from the artist's own blood. I feel both the chill sense of an intellectualization in my response—this work is "about" mortality, making art in the age of AIDS, the futility of art's wager against time—and a more visceral, elemental sensation of being in the presence of beauty. Sometimes it feels as if tears, perhaps tears of blood, might be the only appropriate response to its cold majesty. As formally perfect as any sculpture, indeed as any work of art in any medium, it persists in time only on account of its electromechanical lifeline, the refrigeration unit that keeps the blood in a solid state. Even this technology is unable to prevent the head from "weathering," which, like the patina on a classical bronze sculpture, merely adds to the poignancy of the object.

But it is not the semantic content of the work that finally contains or produces the wonder of this art; it is its knowing fragility. I do not mean to point to the literal fragility of the object even though certain aspects of its materiality intrigue me, cue my curiosity. I want to touch the object, feel its temperature, smell the blood. I certainly feel a physical register to my response—almost as if the somatic responds in its own terms, on its own account. Hence at one moment I am keenly aware of the absence of skin and bone—as if the head in front of me has been flayed—while at another the pose of the artist seems to take on a set of resonances that idealize sculpture or casting the head as a form. In these moments I want to place *Self* in a history of sculpted and cast forms: I call to mind the craggy ruggedness of Giacometti's heads or the simple purity of shape and form I find in Gaudier Breszka's hieratic head, or Henry Moore's morphing of the human body into dazzling contour. When this happens the frozen blood seems to transmute into different material

forms, into bronze or stone. And then I find myself wondering about the pose struck by the artist, if indeed it should properly be called a pose. Is this the cold but finally arid triumph of art, the ultimately unsuccessful wager against time: Shelley's "sneer of cold command"? Or is it resignation, equanimity in the face of that defeat, in the knowledge that at the end of time all one can do is accept, as gracefully as is humanly possible, the fact of solitude?

It sometimes feels as if this is the pose of prayer, and when this occurs a corresponding sense arises in me: the calm inward agitation associated with the activity of praying. But then again the pose seems lifeless, without the sustaining life-blood of percipience. It remains inert, frozen in front of me, both blind and dumb, a reminder of the dark interior secret of knowing otherwise, a stark outpost of the resistance to propositional knowledge: a monument to art's wonder.

But at the end of this itinerary I find dignity: facing up to the transient nature of being human. This work, in a profound way, teaches me the value of dignity, the slow but finally telling realization of the acceptance of solitude. And behind or alongside all this I sense fragility: this might be called the cognitive component of my *aesthetic* response. This helps me to understand why I am moved so powerfully by this sculpture: its state of fragility chimes so clearly with the vulnerability, the evanescence of art's wonder, the sense I have of knowing this for myself as only I can, yet feeling the pressure toward the habitation of a shared knowing. Here I feel familiar, on nodding terms at least, with the wonder that results from the acceptance of solitude, and I know this as deeply in the presence of *Self* as any other place art has led me.

Notes

Sources

Index

Notes

1. Introduction

1. I. A. Richards, *Practical Criticism: A Study of Literary Judgment* (New York: Harcourt, Brace, 1929), p. 217.

2. Serenity

1. Barnett Newman, *Selected Writings and Interviews* (Berkeley: University of California Press, 1990), p. 256.
2. Reprinted in *Abstract Expressionism: A Critical Reader*, ed. David Shapiro and Cecile Shapiro (Cambridge, England: Cambridge University Press, 1990), pp. 346–347.
3. Robert Hughes, *The Shock of the New* (London: Thames and Hudson, 1991), pp. 314, 318. The other members of the "theological wing" were Clyfford Still and Mark Rothko.
4. Newman, *Selected Writings*, p. 183.
5. Ibid., p. 272.
6. Quoted in Jean François Lyotard, "Newman: The Instant," in *The

Lyotard Reader, ed. Andrew Benjamin (Oxford: Basil Blackwell, 1989), p. 247.

7. Newman, *Selected Writings,* p. 173.
8. Ibid.
9. Ibid.
10. Ibid.
11. Quoted in Lyotard, "Newman: The Instant," p. 247.
12. Ibid., p. 257.
13. Ibid., p. 273.
14. Ibid., p. 250.
15. Ibid., p. 178.

3. Clarity

1. Edward W. Said, *Musical Elaborations* (New York: Columbia University Press, 1991), p. 25.
2. *The Glenn Gould Reader,* ed. Tim Page (London: Faber and Faber, 1987), p. 7.
3. Ibid.
4. Liner notes to Mozart, *The Complete Piano Sonatas, Fantasias, K. 397 & K. 475,* Sony Classical, SM4K52627.
5. Andras Schiff, *The Goldberg Variations,* Decca 417 116-2.
6. Andrei Gavrilov, *The Goldberg Variations,* Deutsche Grammophon, DG 435436-2.
7. *Glenn Gould Edition,* Sony SMK52 685.
8. Rosalyn Tureck, *Goldberg Variations,* Vai Audio VAIA1029.

4. Equanimity

1. Stanley Cavell, *Pursuits of Happiness* (Cambridge, Mass.: Harvard University Press, 1981), p. 35.
2. *The Poetical Works of William Wordsworth,* ed. E. de Selincourt and Helen Darbyshire, 5 vols. (Oxford: The Clarendon Press, 1949), I, 440.
3. Ibid., I, 439.

Sources

Introduction: Aesthetic Experience

The general literature on aesthetics is extensive. I have found the best recent introduction to the subject to be Noel Carrol, *Philosophy of Art: A Contemporary Introduction* (London: Routledge, 1999), but see also George Dickie, *Introduction to Aesthetics: An Analytic Approach* (Oxford: Oxford University Press, 1997); George Dickie, *The Century of Taste* (Oxford: Oxford University Press, 1996); and Peter Kivy, *Philosophies of Arts: An Essay in Differences* (Cambridge, England: Cambridge University Press, 1997).

The professional philosophical literature is equally large, but a recent book by Stephen Davies, *Definitions of Art* (Ithaca, N.Y.: Cornell University Press, 1991), contains a lengthy bibliography that is a good starting point for further reading. See also Robert Stecker, *Artworks: Definition, Meaning, Value* (University Park, Penn.: The Pennsylvania State University, 1997).

An entire bibliographical essay would hardly do justice to the literature on Kant's *Critique of Judgment.* Among recent publications I have found the following extremely helpful and thought-provoking: Thierry de Duve, *Kant*

after Duchamp (Cambridge, Mass.: MIT Press, 1996); Gerard Genette, *The Aesthetic Relation* (Ithaca, N.Y.: Cornell University Press, 1999); and Jean-Marie Schaeffer, *Art of the Modern Age* (Princeton, N.J.: Princeton University Press, 2000).

Chapter 2: Serenity

Most of the literature on Newman is contained in exhibition catalogues and includes the following: Thomas B. Hess, *Barnett Newman* (New York: The Museum of Modern Art, 1971); Yves-Alain Bois, *Barnett Newman: Paintings* (New York: The Pace Gallery, 1988); Harold Rosenberg, *Barnett Newman* (New York: Harry N. Abrams, 1978); *The Sublime Is Now: The Early Work of Barnett Newman* (New York: The Pace Gallery, 1994).

A selection of Newman's writings has been collected in *Barnett Newman: Selected Writings and Interviews* (New York: Knopf, 1990).

Chapter 3: Clarity

There is a growing body of work on Gould. See, for example, Otto Friedrich, *Glenn Gould: A Life and Variations* (London: Octopus, 1990); Edward Said, *Musical Elaborations* (New York: Columbia University Press, 1991); Kevin Bazzana, *Glenn Gould: The Performer in the Work* (Oxford: Clarendon Press, 1997); Peter F. Ostwald, *Glenn Gould: The Ecstasy and Tragedy of Genius* (New York: W. W. Norton and Company, 1997).

Gould's writings and interviews have appeared in *The Glenn Gould Reader*, ed. Tim Page (New York: Knopf, 1984); and Jonathan Cott, *Conversations with Glenn Gould* (Boston: Little, Brown and Company, 1984). Some letters have been chosen in *Glenn Gould: Selected Letters*, ed. and comp. John P. L. Roberts and Ghyslaine Guertin (Toronto: Oxford University Press, 1992).

The literature on Bach is voluminous; for a good selective guide see *The Cambridge Companion to Bach*, ed. John Butt (Cambridge, England: Cambridge University Press, 1997).

Chapter 4: Equanimity

The secondary literature on Wordsworth is extensive. For a good recent guide see *An Annotated Critical Bibliography of William Wordsworth*, ed. Keith Hanley, assisted by David Barron (London: Prentice Hall, 1995). Of the many discussions of *We Are Seven* to be found in this literature, the one I wish I had read before penning my own is to be found in Frances Ferguson's *Solitude and the Sublime* (London: Routledge, 1992).

Index

Index